Baroque Cartouches

for Designers and Artists

Baroque Cartouches

for Designers and Artists

136 PLATES FROM THE 'HISTORISCHE BILDER-BIBEL'

DESIGNED AND ENGRAVED BY

JOHANN ULRICH KRAUSS

with an introduction by *Edward A. Maser*

PROFESSOR OF ART, THE UNIVERSITY OF CHICAGO

Dover Publications, Inc., New York

Published in Canada by General Publishing Company, Ltd.,
30 Lesmill Road, Don Mills, Toronto, Ontario.
Published in the United Kingdom by Constable and Company, Ltd.,
10 Orange Street, London WC 2.

Baroque Cartouches for Designers and Artists, first published by
Dover Publications, Inc., in 1969, comprises all the cartouches
from Johann Ulrich Krauss' *Historische Bilder-Bibel,* originally
published by the artist in Augsburg in five parts between 1698 and
1700, brief identifications of the Biblical scenes, and a new intro-
duction by Edward A. Maser written especially for the present
edition.

Standard Book Number: 486-22222-5
Library of Congress Catalog Card Number: 69-16808

Manufactured in the United States of America

Dover Publications, Inc.
180 Varick Street
New York, N. Y. 10014

Introduction

The French word *cartouche,* which is the form used in English-speaking countries, actually derives from the Italian word *cartoccio,* meaning a roll or twist of paper. In the context of the history of ornament, this was the little scroll of paper, torn and curling at the edges, often to be found in fifteenth-century paintings, which bore the artist's signature or the date or some such relevant information. From that time on, the ornamental possibilities of the edges of these scrolls inspired designers to seek variations in their treatment, leading to their sometimes being converted into tablets with borders derived from architectural mouldings, or shield forms with naturalistic or abstract objects forming a framework around the clear space in the center, which was to receive some inscription or name or motto or coat of arms. Thus these tattered paper edges became with time the very popular ornamental form of the "surround" or frame—in short, the cartouche.

By the seventeenth century, the cartouche had become one of the standard components of the ornamental vocabulary of artists and craftsmen throughout Europe. It was used, moreover, not only in pictures, but in all manner of decoration—for the stucco ornament of a wall or ceiling, for the title pages of books, for the carved decoration of furniture or for the engraved designs on silver utensils. Particularly during the Baroque period, the seventeenth and eighteenth centuries, it reached a peak of imaginative treatment, with a luxuriance of decorative elements, combined and blended in fantastic ways, that has never been equaled in the history of art.

From the very beginning of printmaking, one of the main functions of woodcuts, engravings and etchings was not only to produce pictures as such, but also to provide reproductions of ornamental forms for the use of artisans, designers and craftsmen of all sorts. Since ornament prints could be reproduced in relatively large numbers and were very easy to transport, they became one of the most important vehicles for the spread of the new styles and fashions in the arts which had begun with the Renaissance. Printed in the form of single sheets or bound as booklets, they soon reached the point where certain types of ornament would be concentrated upon, providing the interested designer with a whole series of variations on a theme: either a specific type of decoration (such as borders or medallions or cartouches) or a specific object (such as candlesticks or vases or mirrors). Sometimes the observation of the chronological development of these ornament prints can give the student the best obtainable idea of stylistic change over a given period.

During the sixteenth and seventeenth centuries, Italy and France were most often the leaders in the production of new designs and the invention of new types of ornament, and the focus of their dissemination across the continent and even beyond the oceans, to the New World and the Orient. By the beginning of the eighteenth century, however, the most imaginative treatments of ornament often came from Germany, where, following the examples of the Latin countries, whole schools of ornament designers developed, making their designs available through the graphic media. Of primary importance was the city of Augsburg in southern Germany. In the eighteenth century a flourishing center of the arts and crafts, chiefly noted for its silversmiths and its workers in stucco, Augsburg was also the home of a large group of ornament designers who provided the local craftsmen with the new designs they needed and produced some of

the finest and most elaborate ornament known. One of these designers, Johann Esaias Nilson (1721–1788), actually became head of the city's academy of art, one of the most famous in Germany. This is evidence, certainly, of the high place in the city's esteem this sort of designing enjoyed.

Another important painter-designer in Augsburg was Johann Ulrich Krauss (1655–1719), the artist who created the ornamental cartouches reproduced in this volume. He belonged to a family of designers which had flourished in Augsburg since the sixteenth century. It was fairly common in southern Germany for entire families to specialize in some branch of the arts, passing down their skills from one generation to the next. The Krauss family was a very numerous one, but its most noteworthy member was Johann Ulrich, who was a print and book publisher as well as an ornament designer. One of his most famous productions was his *Historische Bilder-Bibel,* a Bible in pictures, from which these cartouches are taken. Published in five parts between 1698 and 1700, the *Bilder-Bibel* was so popular that it immediately had a second printing in 1700 and a third in 1705.

One reason the *Bilder-Bibel* was so popular was that unlike other publishers of such books (there had been a good number from the first half of the sixteenth century), Krauss, although a Protestant, did not emphasize either Protestant or Catholic ideas in his work. Indeed, in 1706 the Catholic publishers of Augsburg complained to the Emperor that men like him were worse than the sectarian Protestant publishers because he appealed to either denomination and was thus able to sell to both of them. But Krauss aimed at an even larger audience for his pictorial Bible. In one of his introductions he clearly stated that the book was aimed at the pious man, the art lover and the *artist.* He was thus quite consciously combining an ornament pattern book with a Bible.

The *Historische Bilder-Bibel* dealt almost exclusively, but not entirely, with the Old Testament; only the last part was concerned with the New. Each page contained two or more small pictures depicting some episode in the Bible, at least one being framed in an elaborate cartouche made up of borders and objects usually appropriate to the scene depicted within. For instance, a scene of war or battle (frequent enough in the Old Testament) might be surrounded by all sorts of allusions to war—drums and banners, cannons and lances, swords and shields— with the figures of the gods of war, Bellona and Mars, seated on either side. Krauss used almost every conceivable theme or ornamental form in decorating the frames around all these scenes, so that they became by far the most imposing and interesting part of the book, overshadowing the small and excessively detailed scenes they were meant to frame.

As was to be expected during the age of Louis XIV, Krauss turned to the great French designers for his ideas. Such books as the great 1692 atlas of the cartographer Nicolas Sanson, which was the main source for the cartouches, and Jean Lepautre's *Trophées médalliques des Seigneurs de Rostaing* of 1661 provided him with the models upon which he based his work. Since in the past absolute originality was not necessarily considered a positive virtue, Krauss was able to take advantage of the rich heritage of the seventeenth-century ornament designers of France and Italy, sometimes borrowing from them outright, and sometimes simply bringing them up to date a bit. He seemed to be especially partial to the acanthus leaf designs of Lepautre, although the influence of Daniel Marot and Jean Bérain is also evident. One of the reasons why Krauss' *Bilder-Bibel* is so important in the history of ornament is that it was the chief vehicle for the spread of the Louis XIV style, as represented in the work of these great designers, throughout Germany. His cartouches became the favored models for a genera-

tion of artist-craftsmen—silversmiths, cabinetmakers and stucco workers—whose widespread use of them gave the *Bilder-Bibel* its true significance.

This volume reproducing the ornamental cartouches from the Krauss *Bilder-Bibel* is intended to serve much the same purpose as the eighteenth-century edition—to provide the designer-craftsman with imaginative decorative treatments of surrounds or frames, which he can adopt or adapt, as his own artistic imagination permits or as the nature of his work demands. It is one further example of the treasures of the past, now made easily available through modern technology, being used to enrich the present and to provide new stimuli and incentives for the creative artist.

1969 EDWARD A. MASER

Some Bibliographical References

BAUER, HERMANN, *Rocaille,* Berlin, 1962.

JESSEN, PETER, *Der Ornamentstich,* Berlin, 1920.

REICHL, OTTO, *Die Illustrationen in vier geistlichen Büchern des Augsburger Kupferstechers Johann Ulrich Krauss,* Studien zur Deutschen Kunstgeschichte, Strassburg, 1933.

THIEME and BECKER, *Allgemeines Lexikon der bildenden Künstler,* Vol. XXI, pp. 440 f.

WARD-JACKSON, PETER, "Some main-streams and tributaries in European ornament, 1500–1750," *Victoria & Albert Museum Bulletin,* Vol. III, no. 4, Oct. 1967, pp. 131–134.

List of Plates

Baroque Cartouches

for Designers and Artists

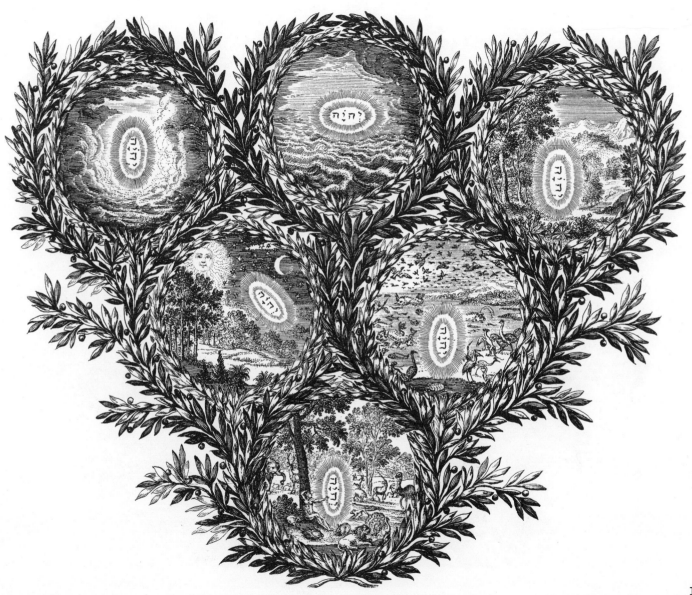

I

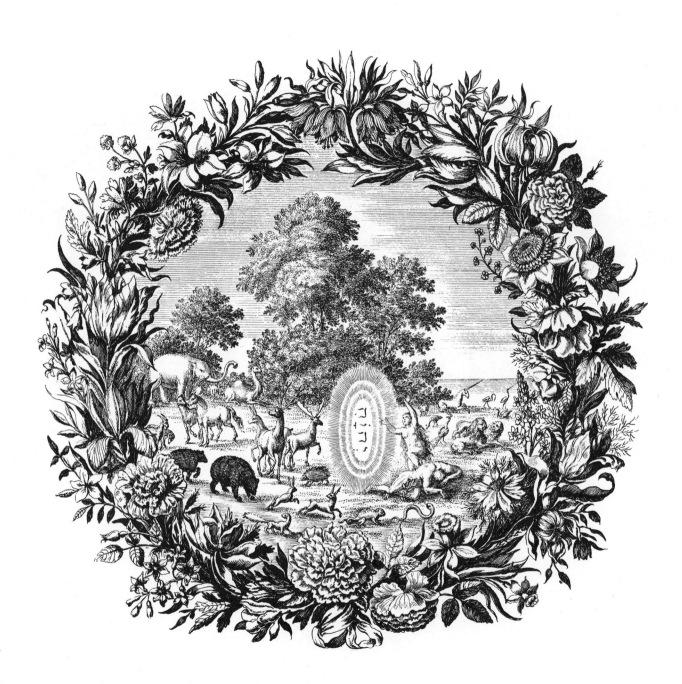

2

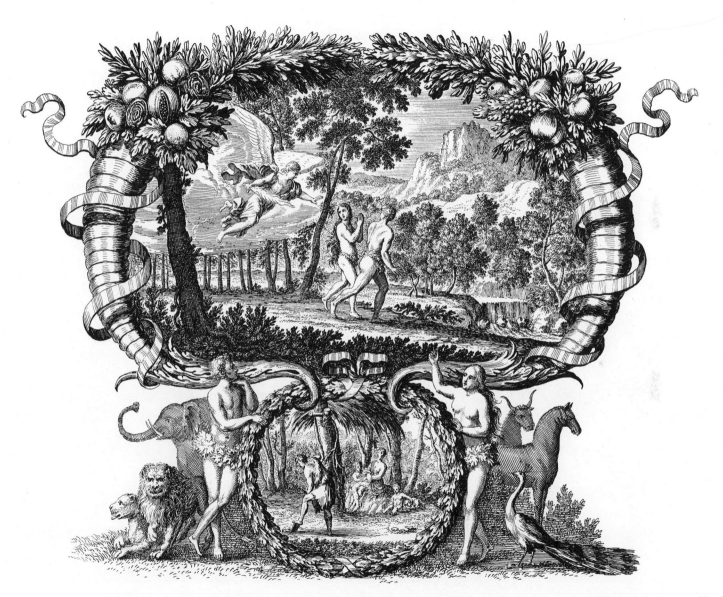

3

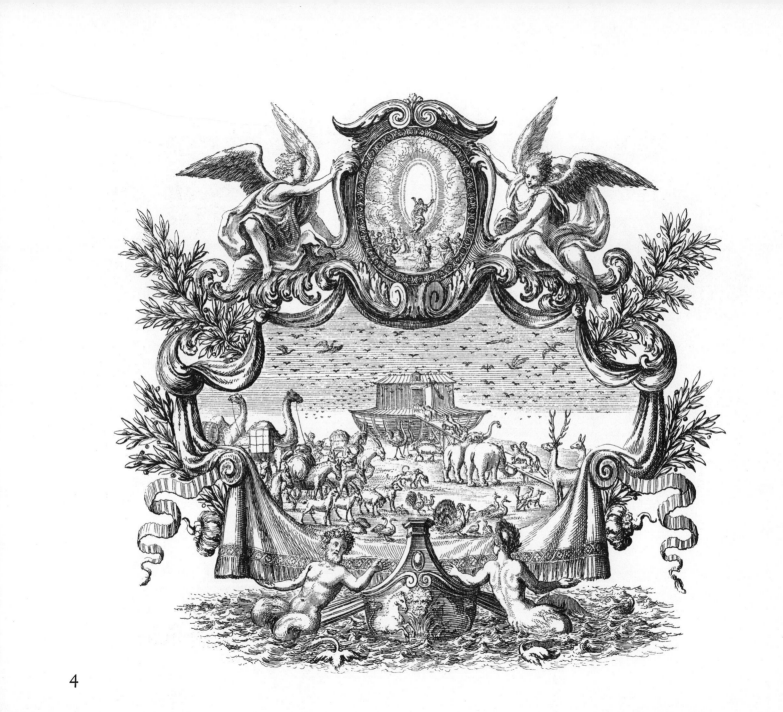

4

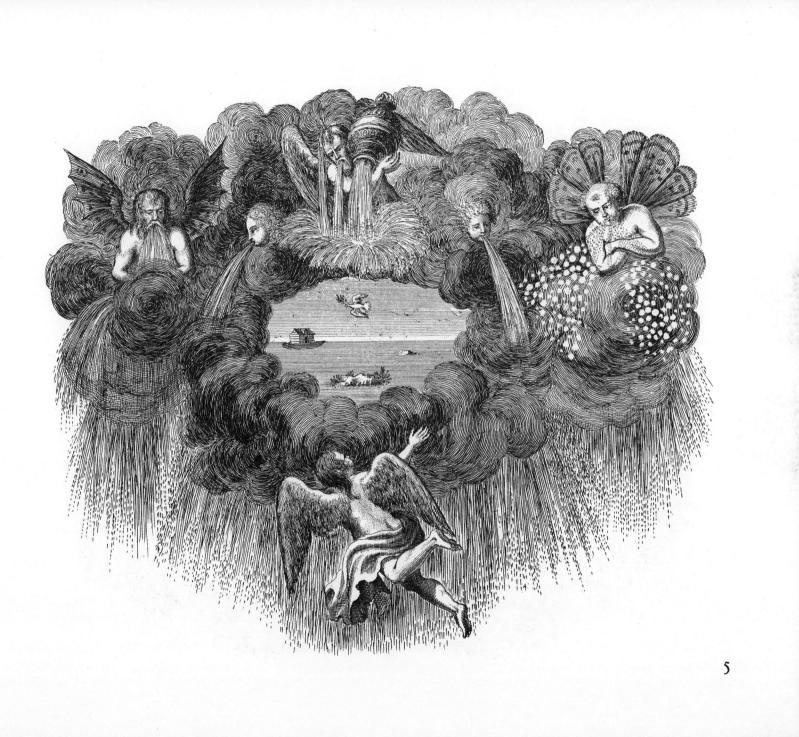

5

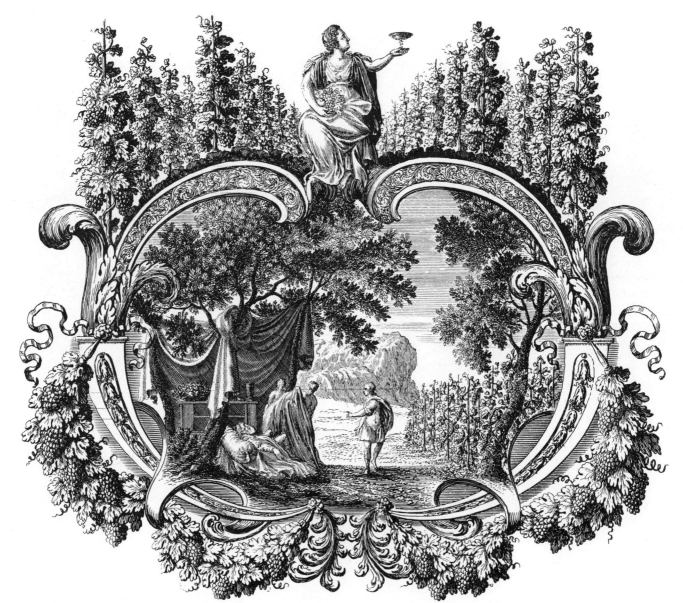

6

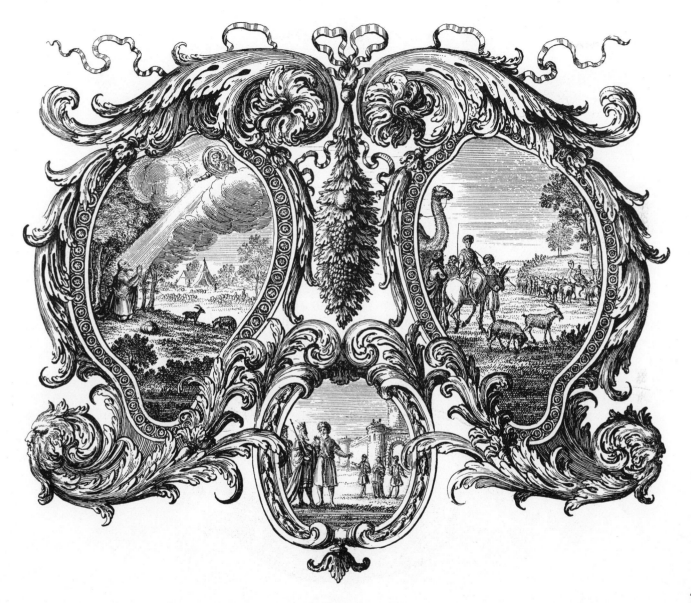

7

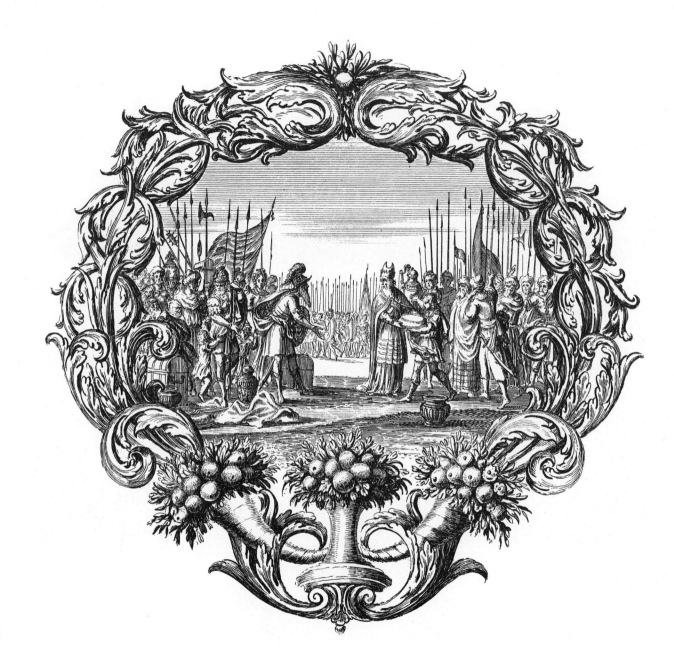

8

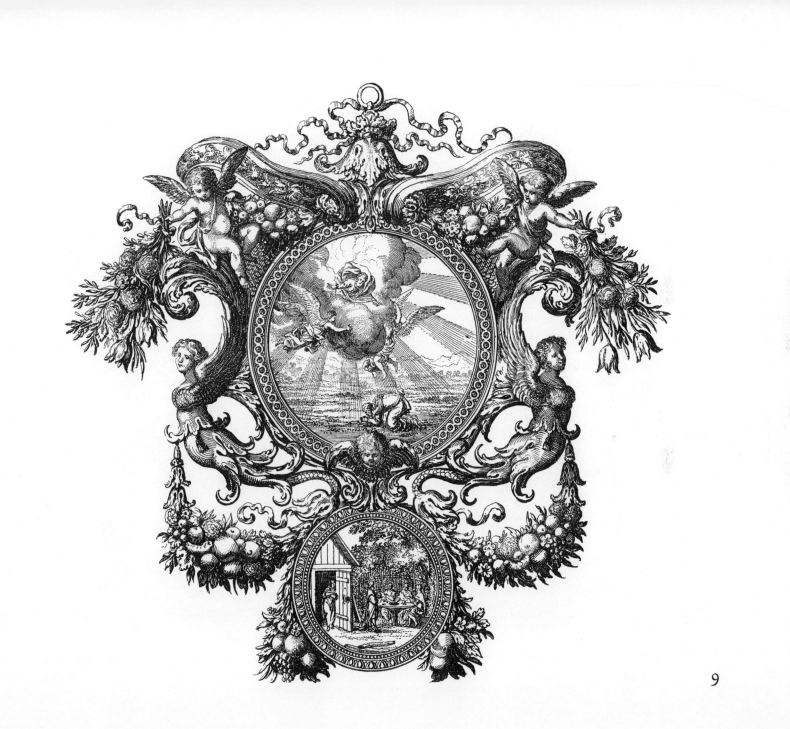

9

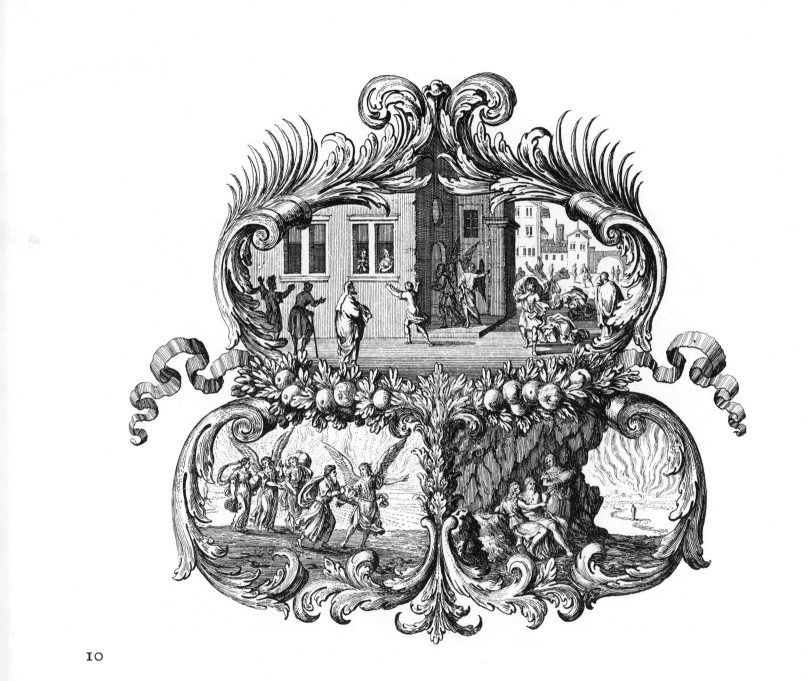

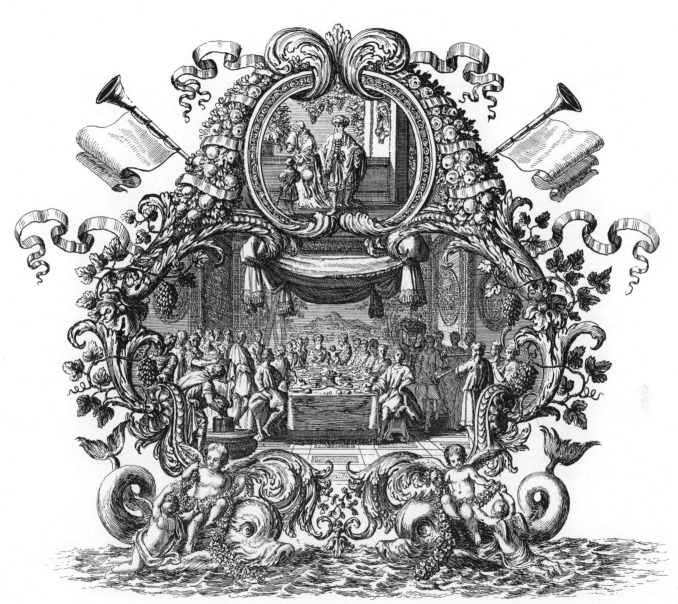

II

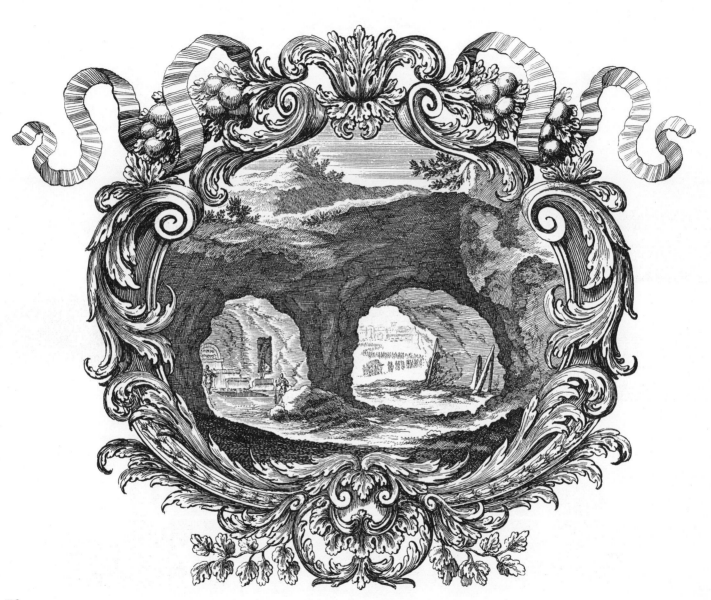

12

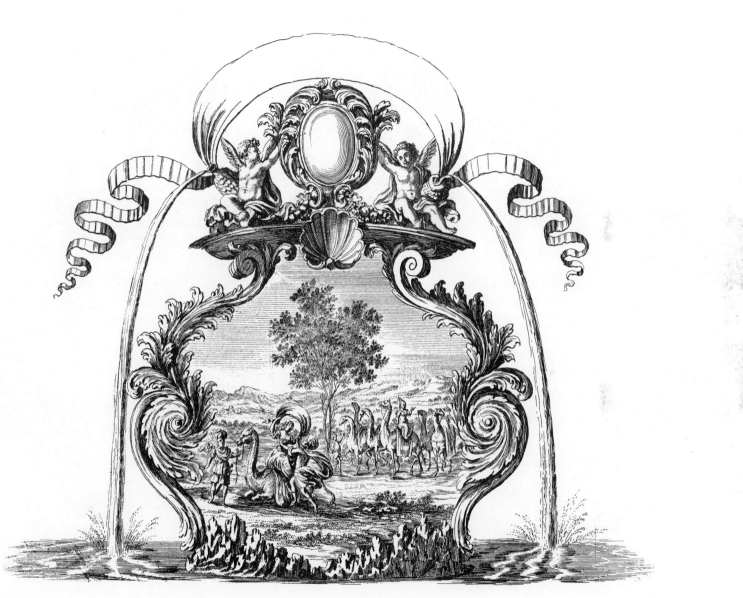

13

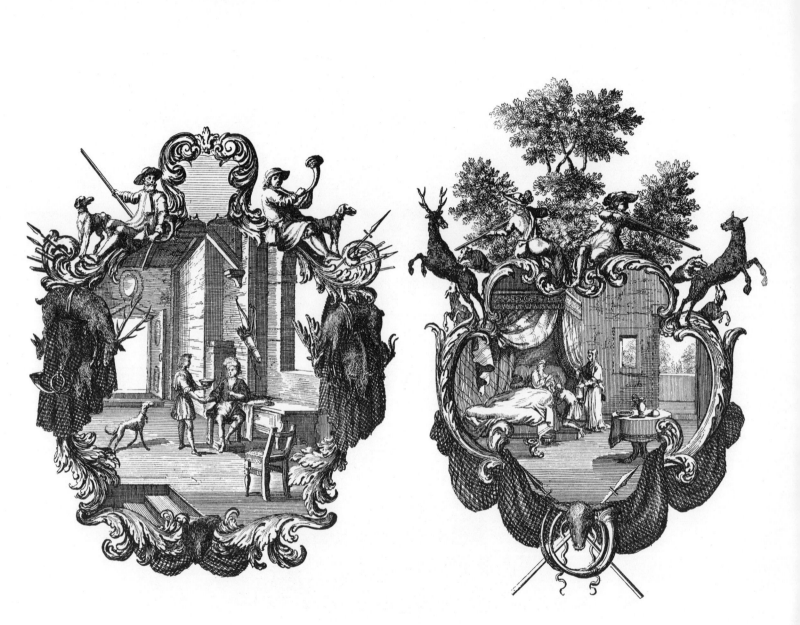

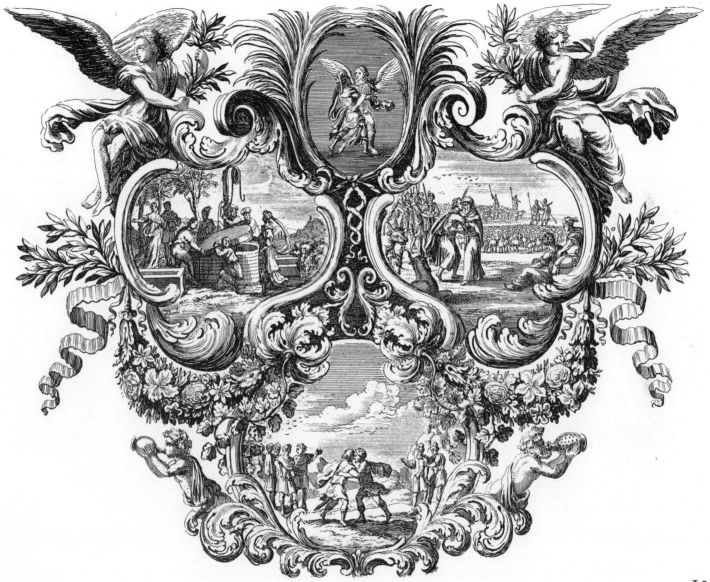

15

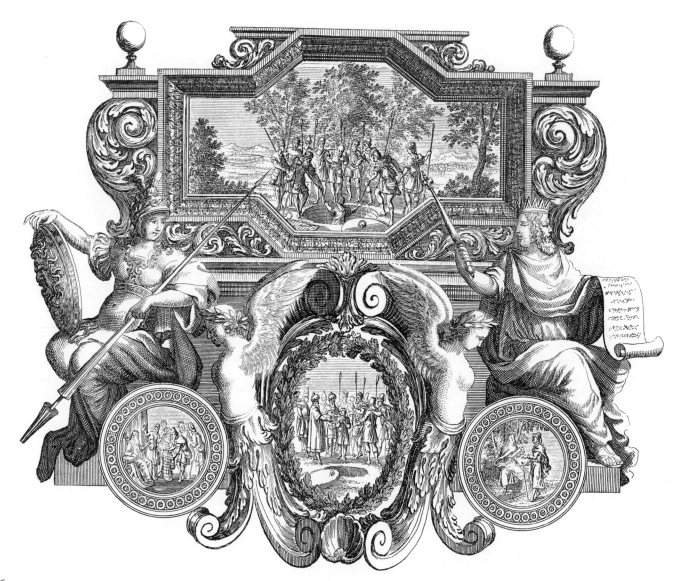

16

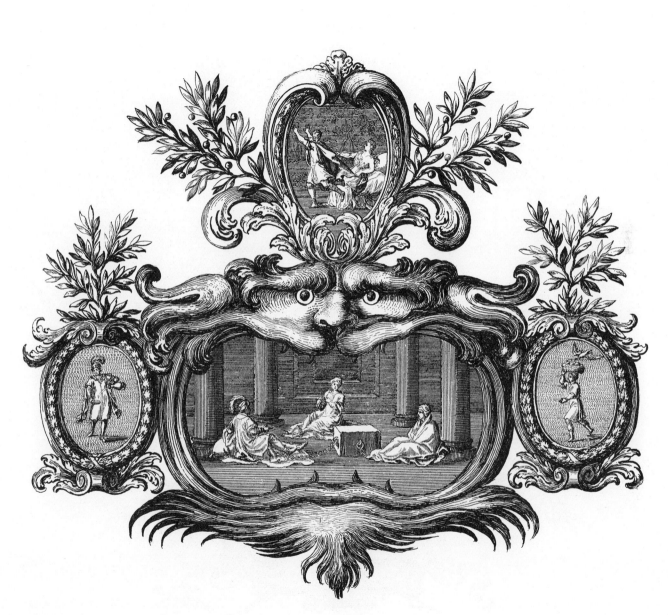

17

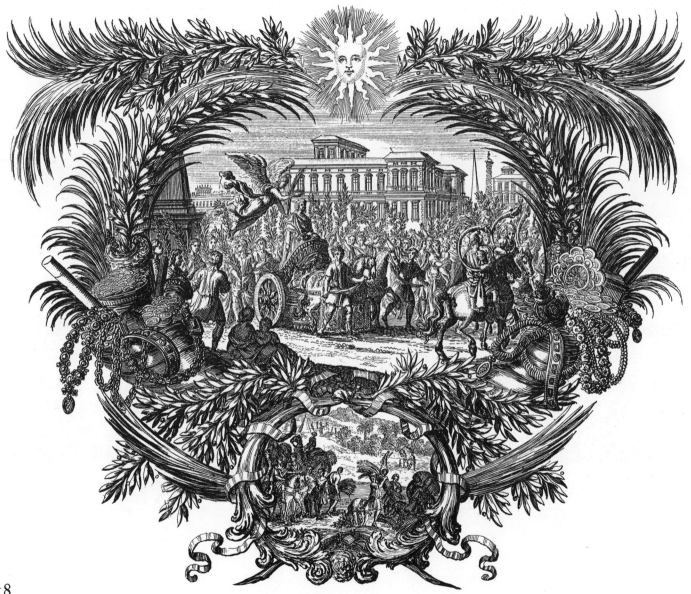

18

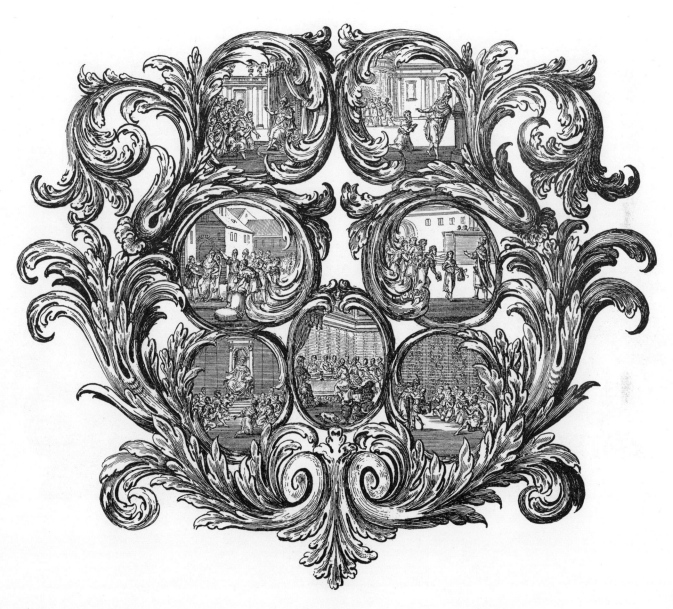

19

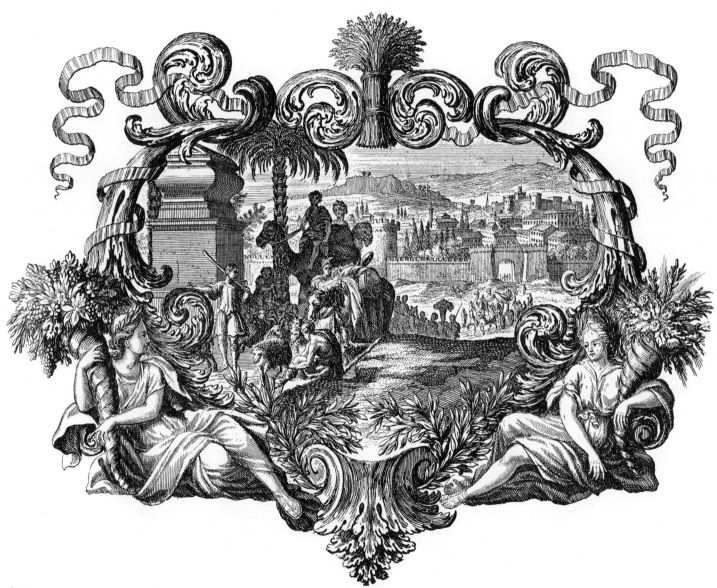

20

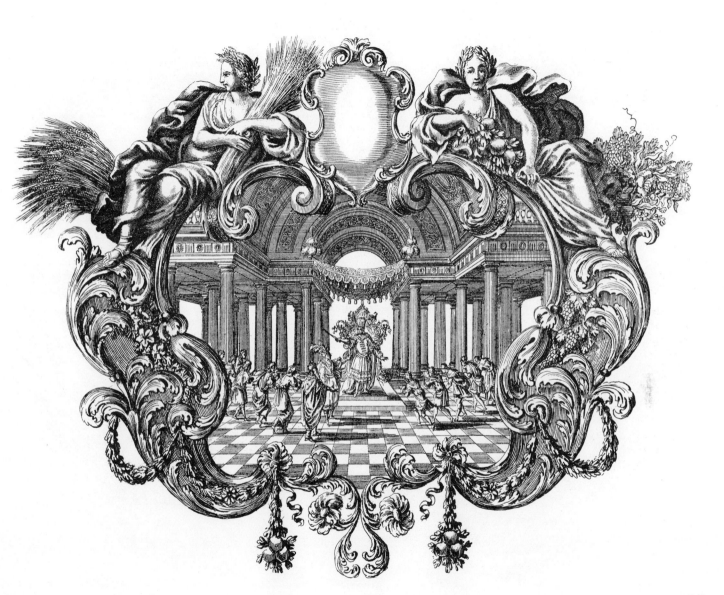

21

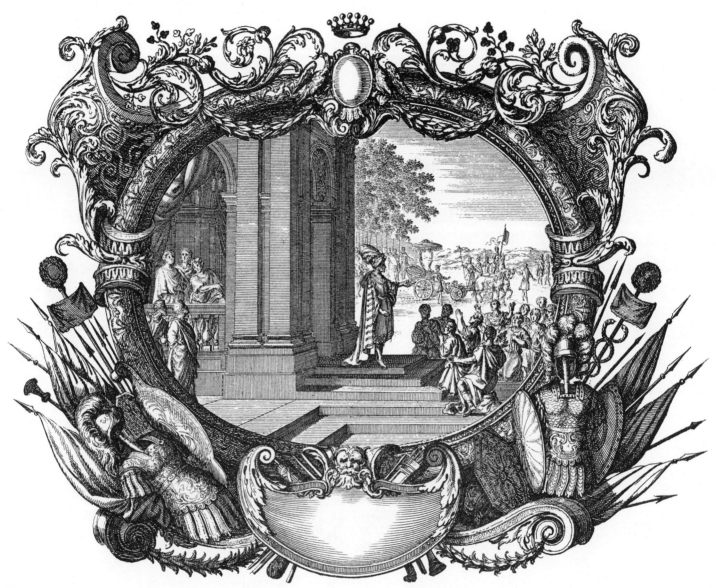

22

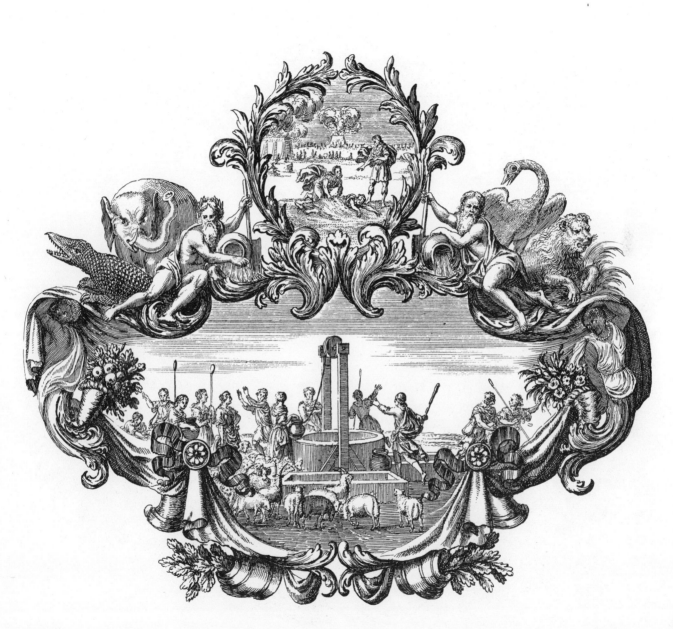

23

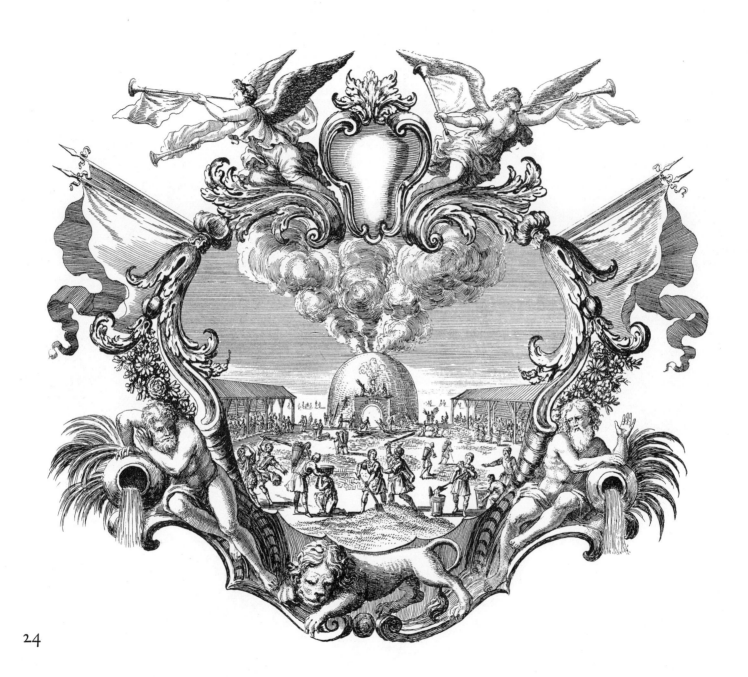

24

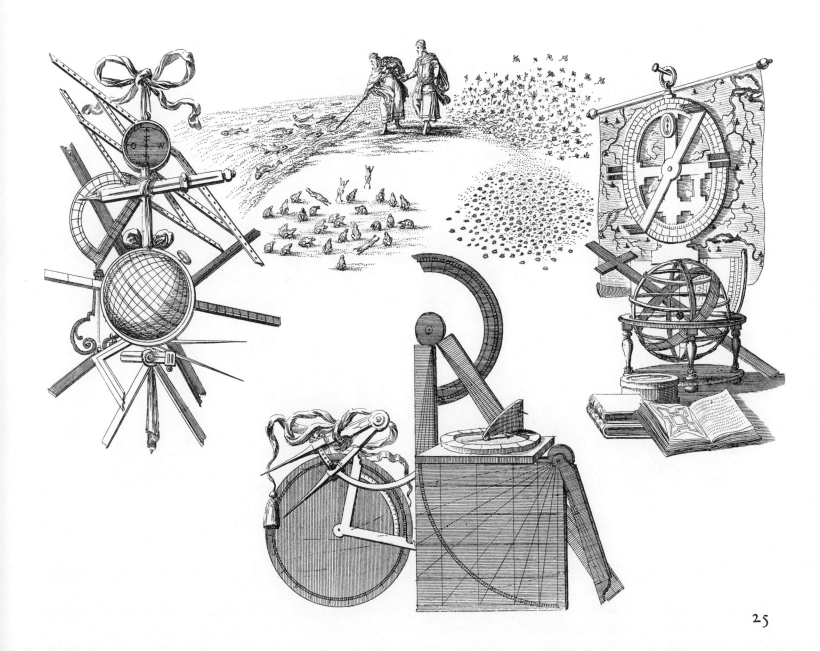

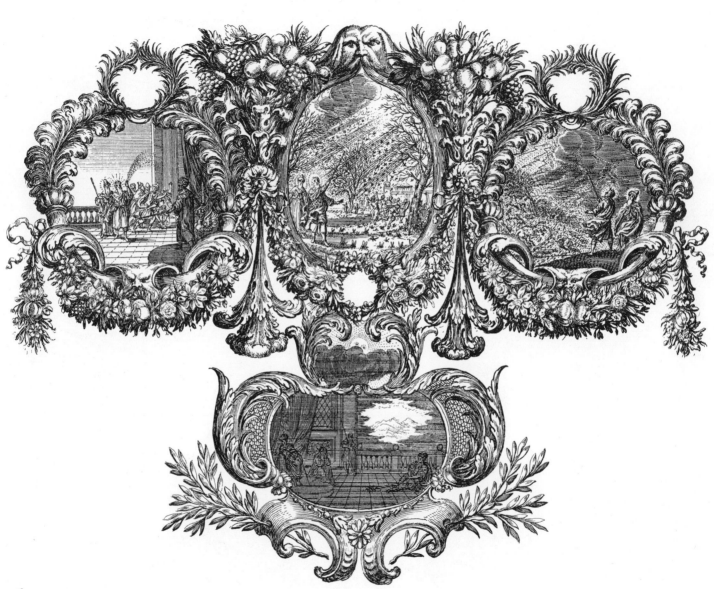

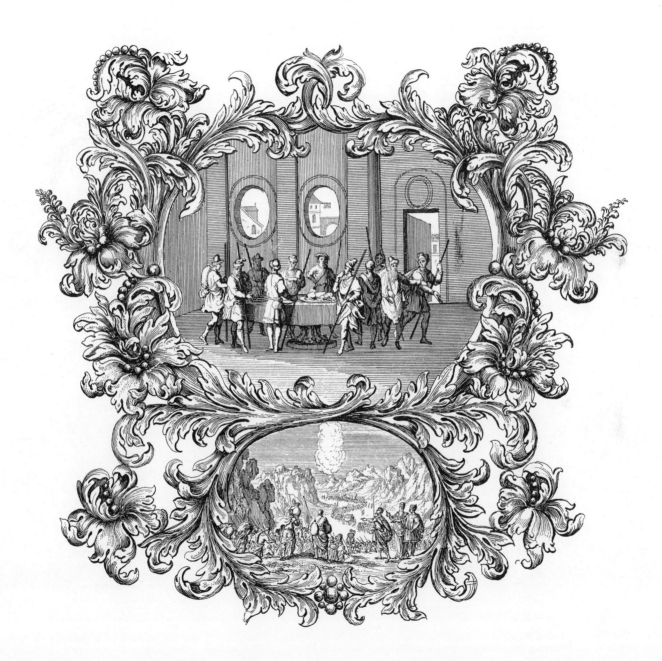

27

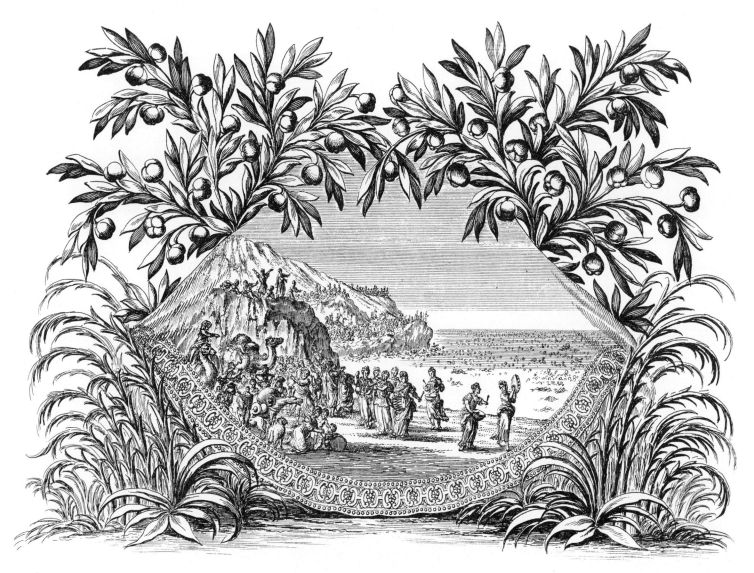

28

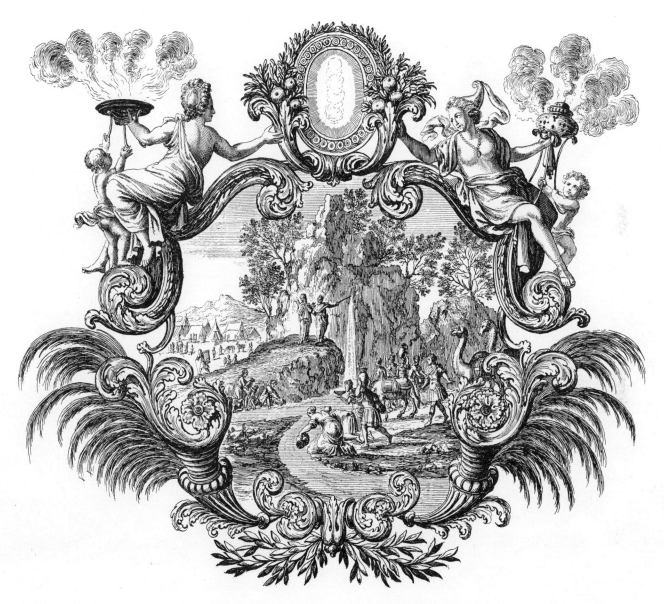

29

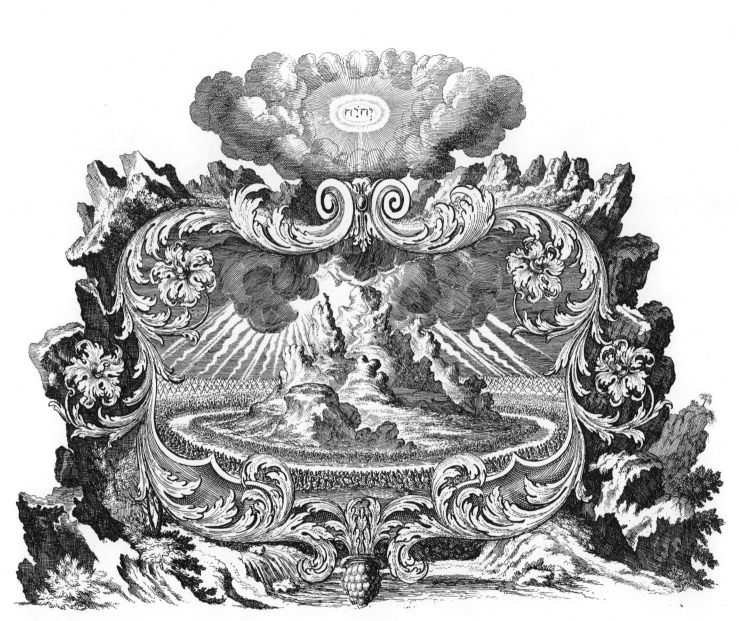

30

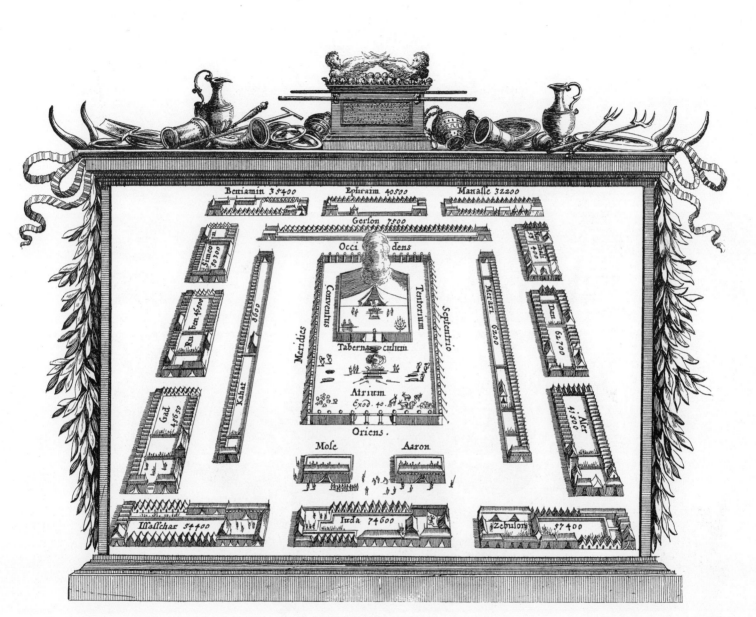

31

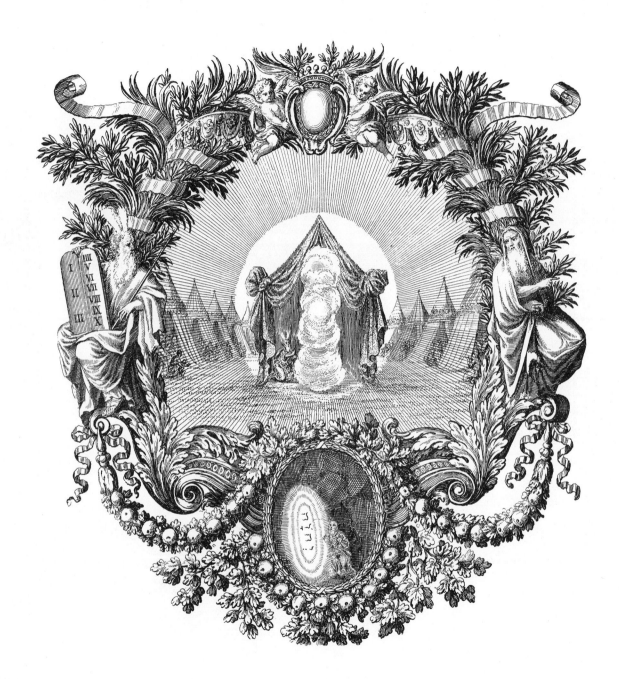

32

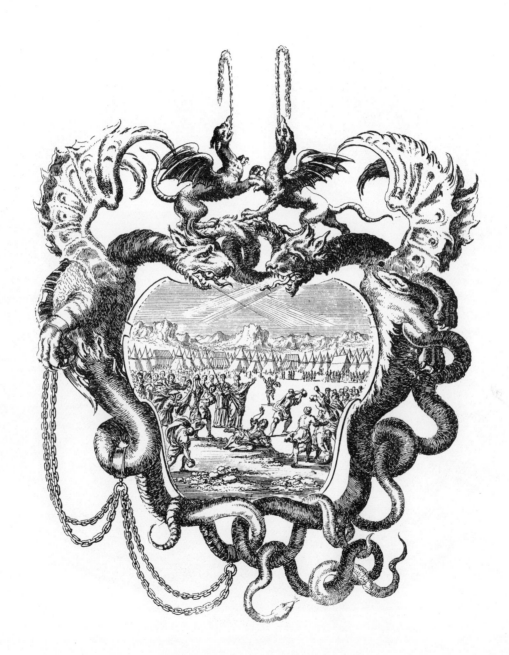

33

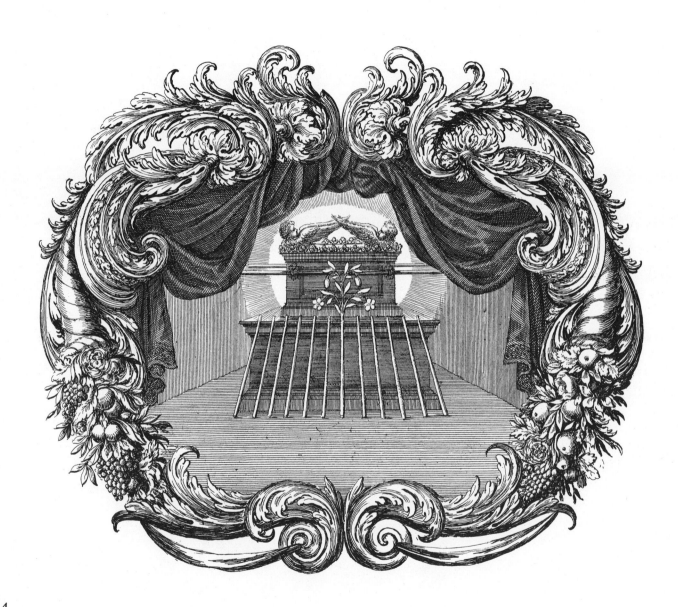

34

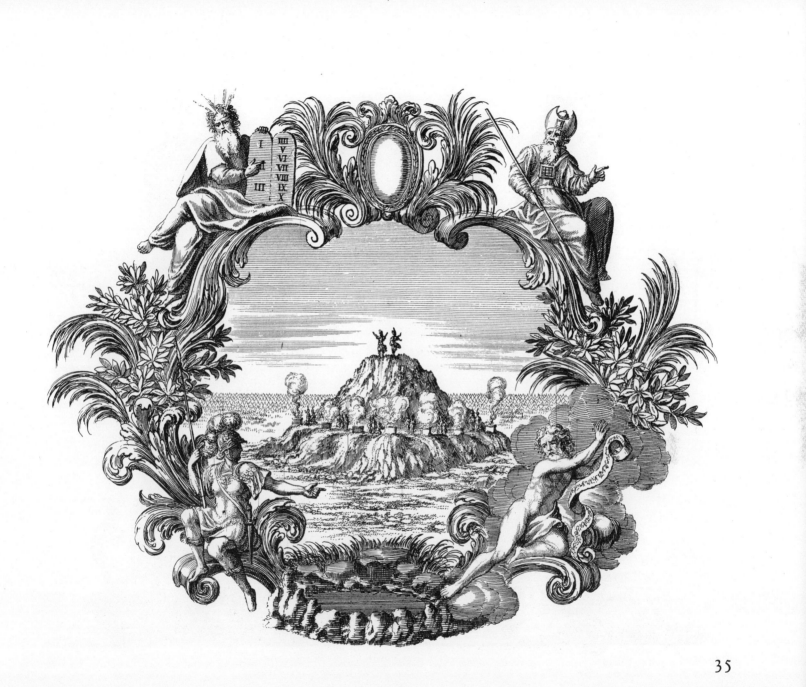

35

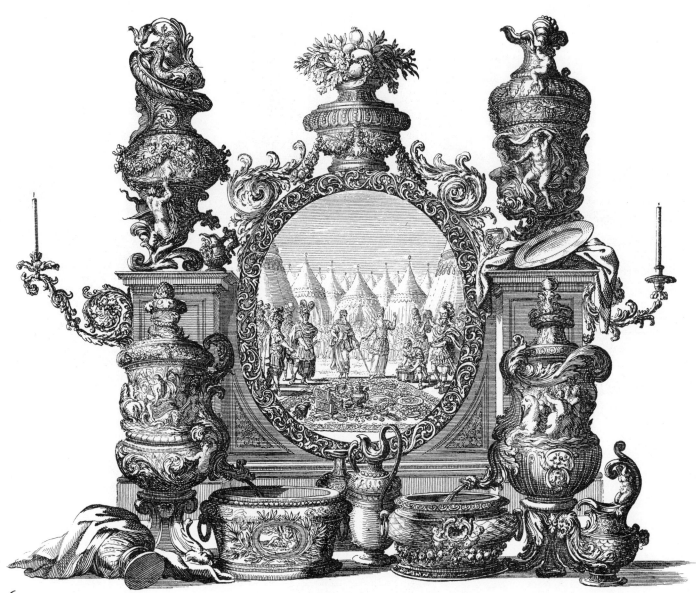

36

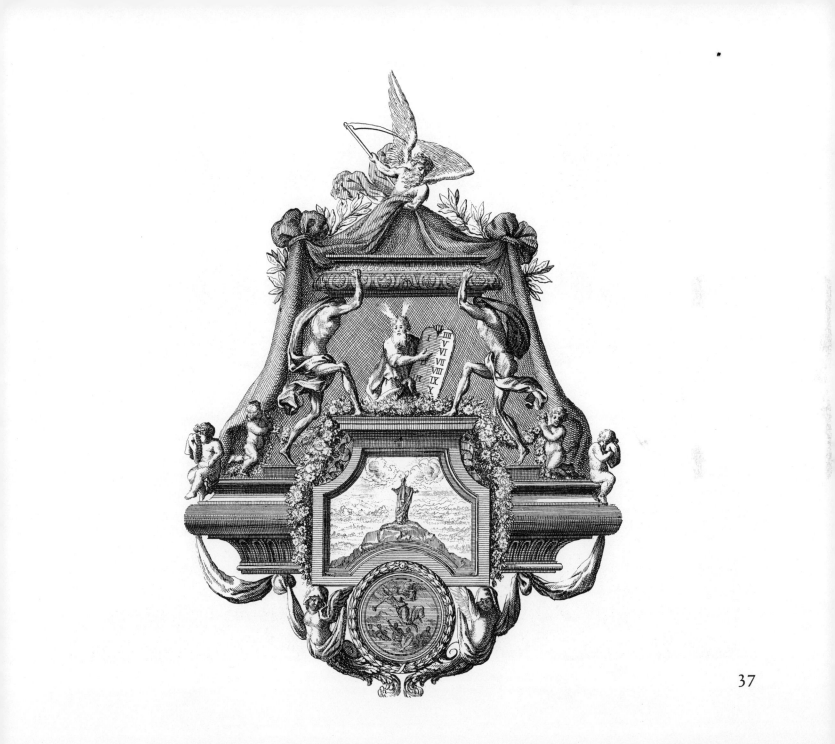

37

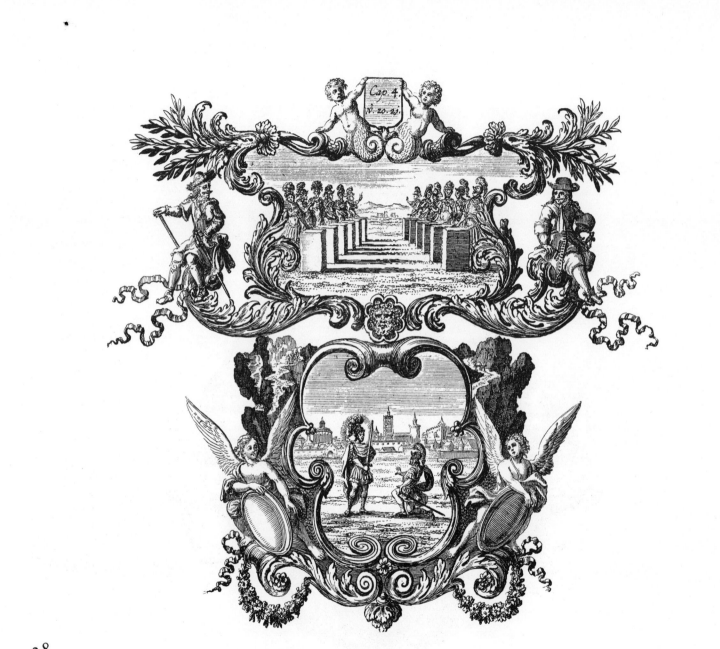

Cap. 4.
N. 20. 21.

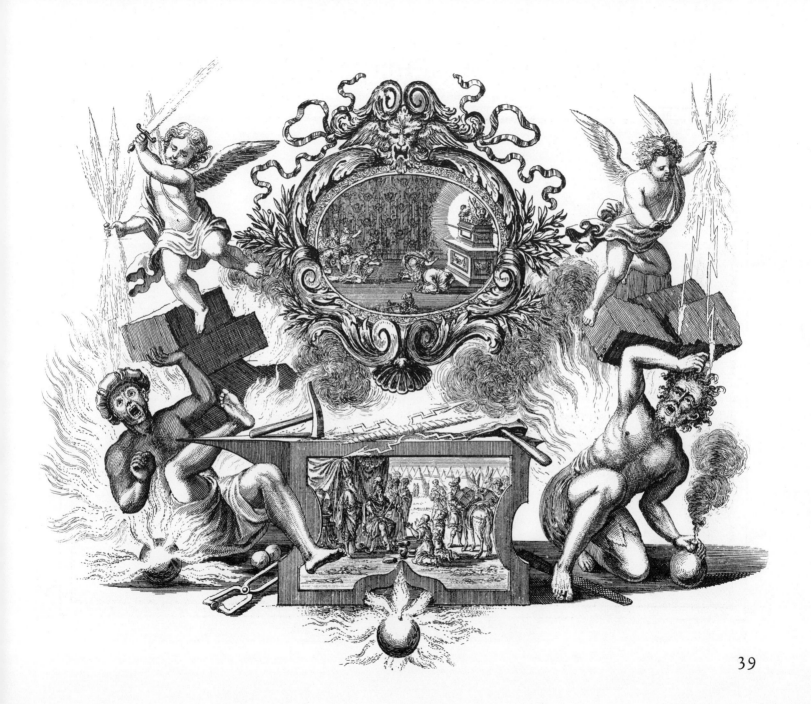

39

IUDÆA seu TERRA SANCTA quæ HEBRÆORUM sive ISRAELITARUM

in suas duodecim Tribus divisa secretis ab invicem Regnis IVDA et ISRAEL

expressis insuper sex ultimi temporis ejusdem Terræ Provincijs.

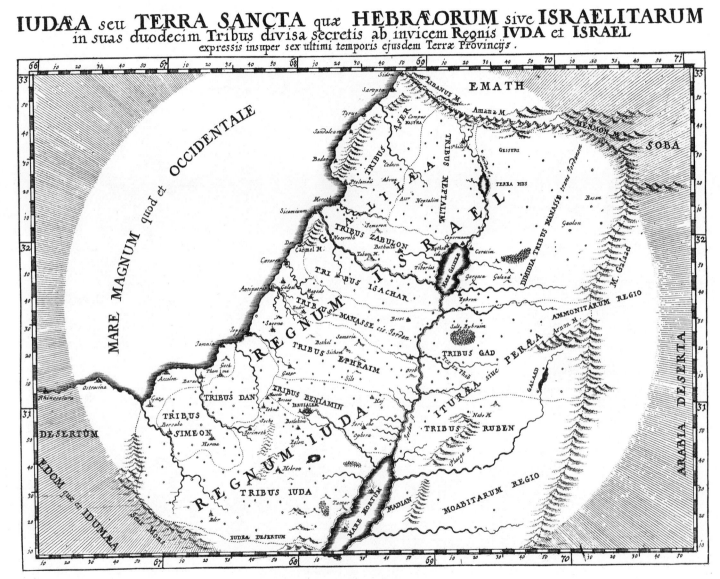

40

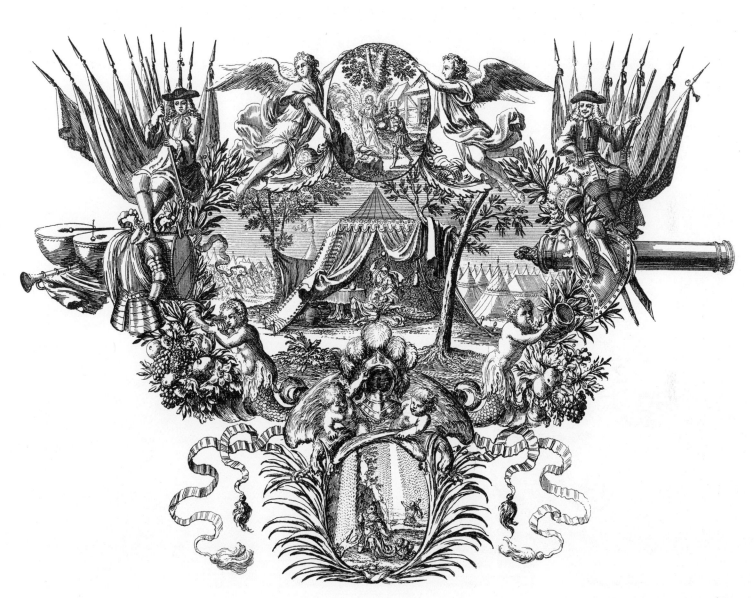

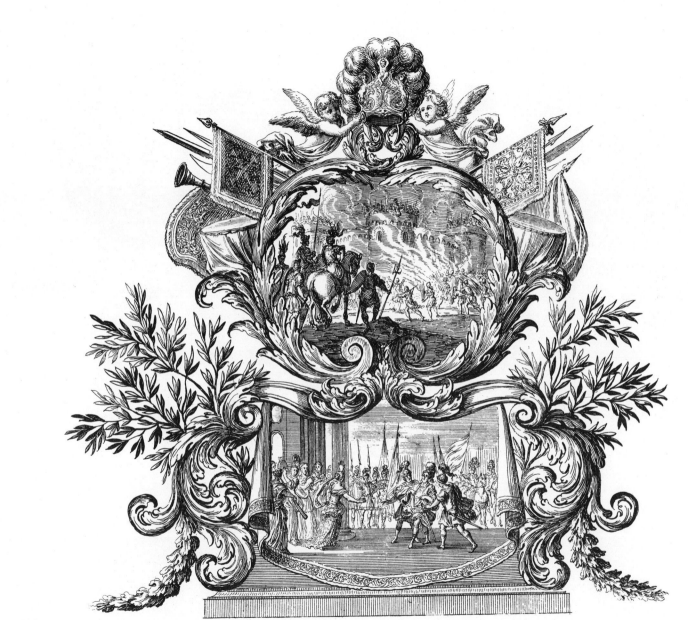

42

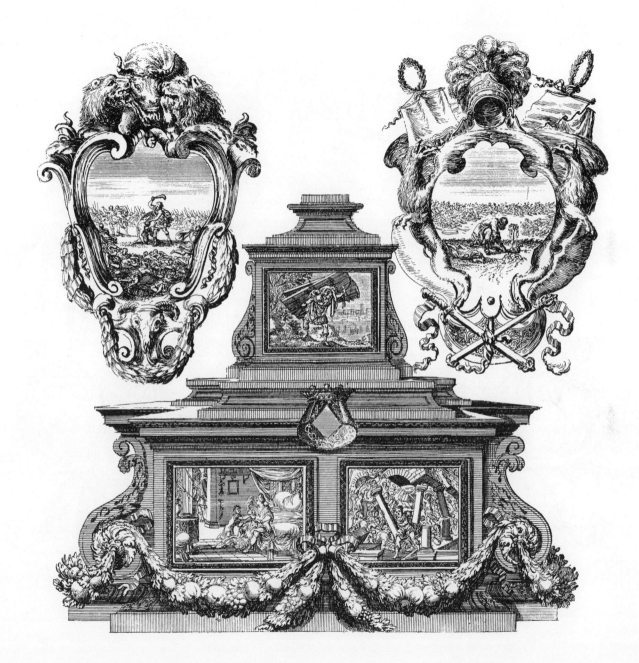

43

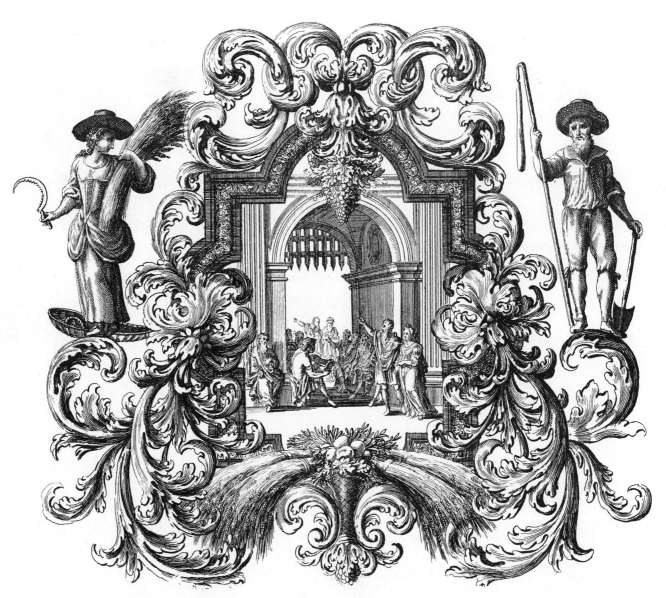

44

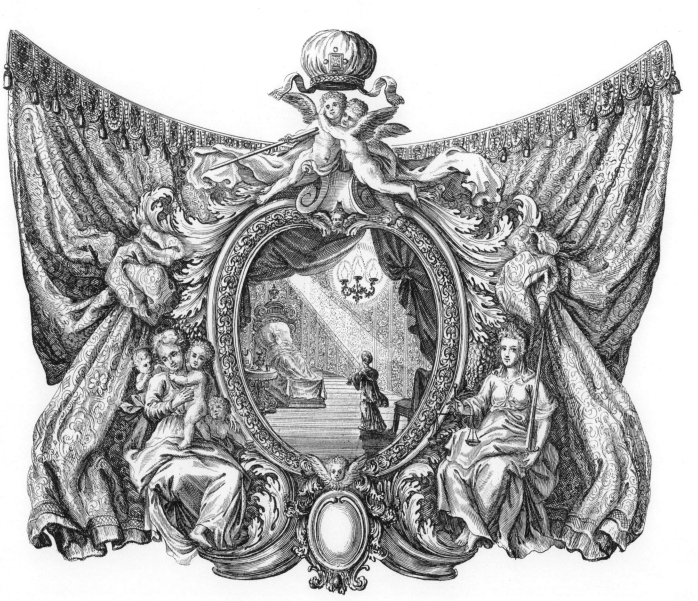

45

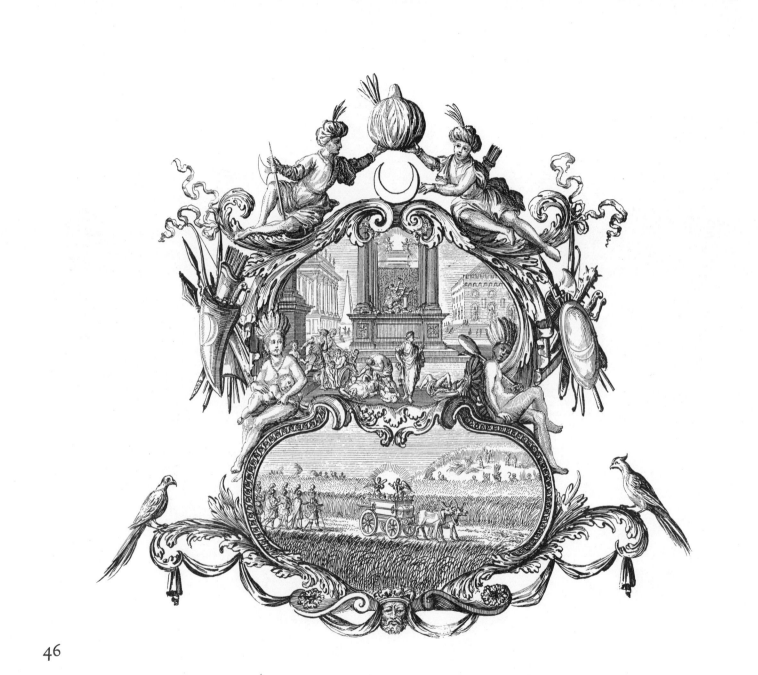

46

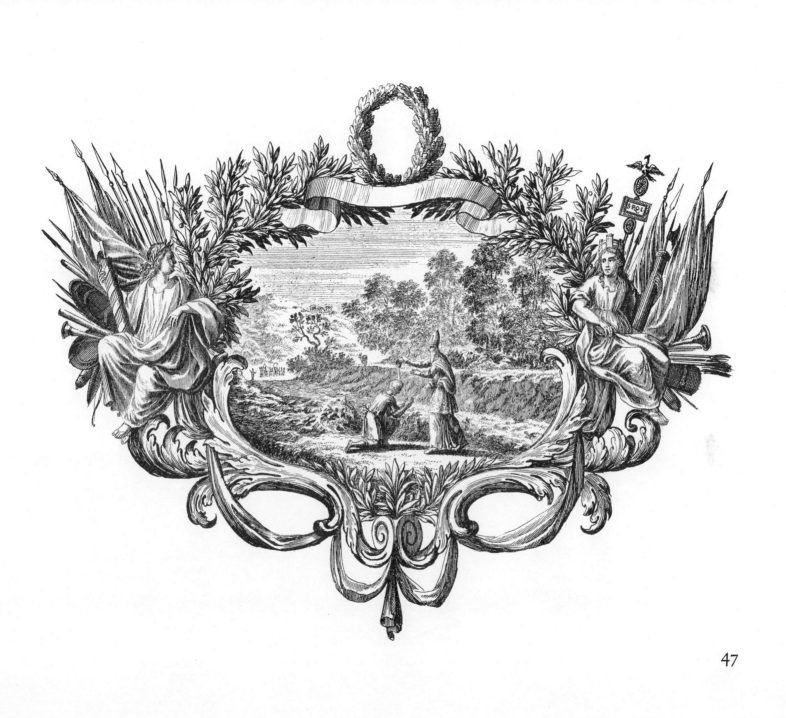

47

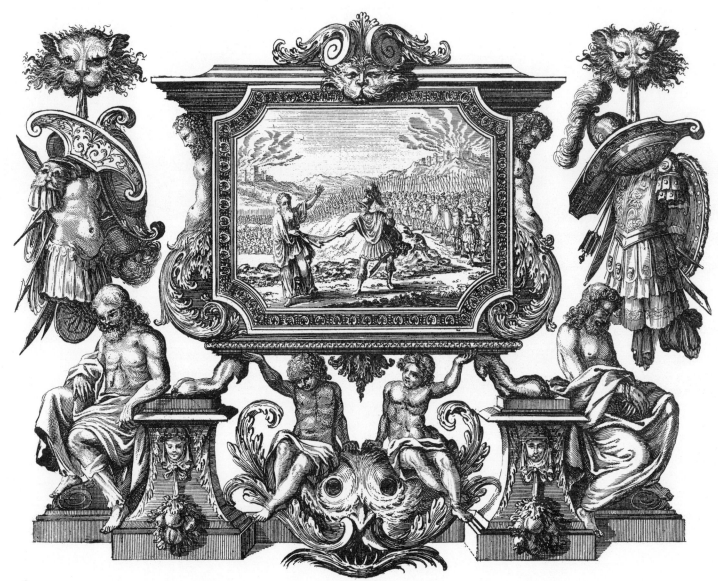

48

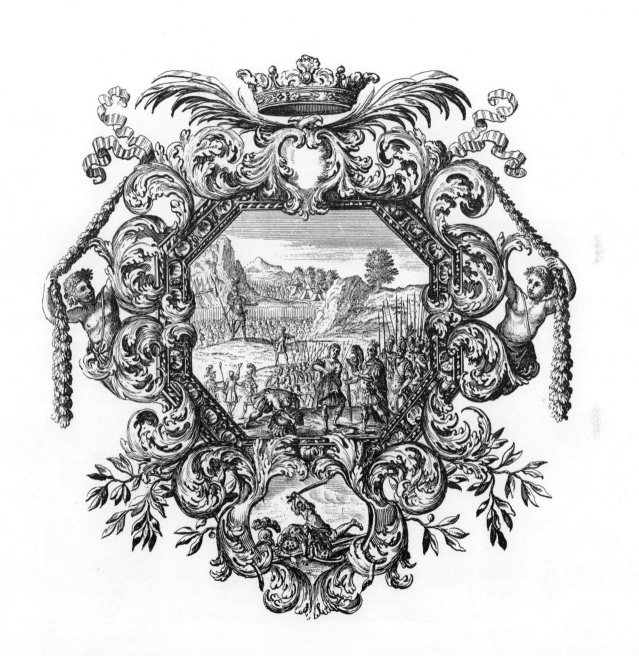

49

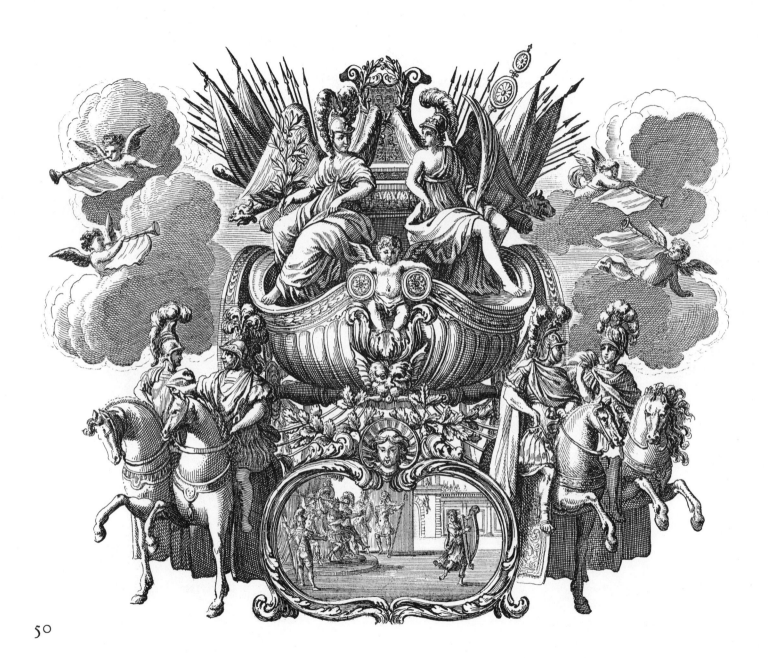

50

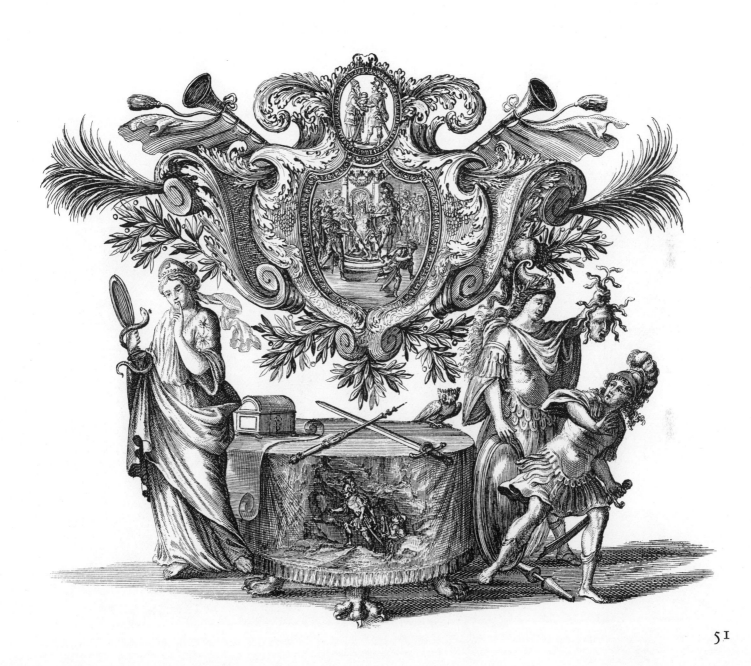

51

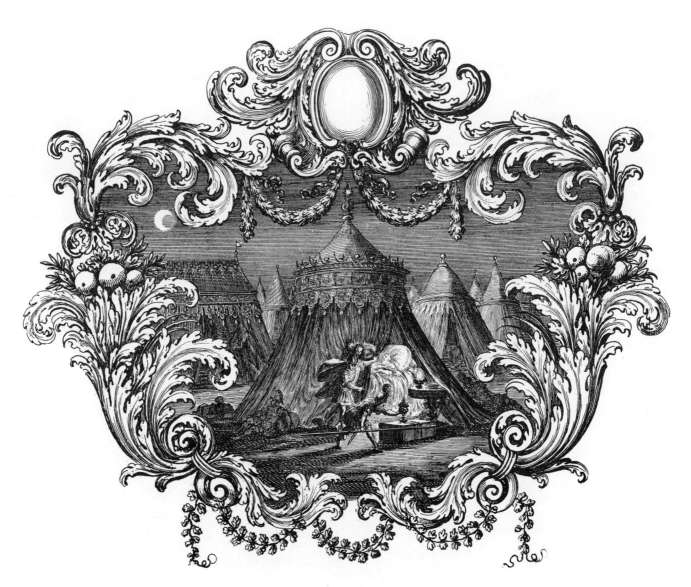

52

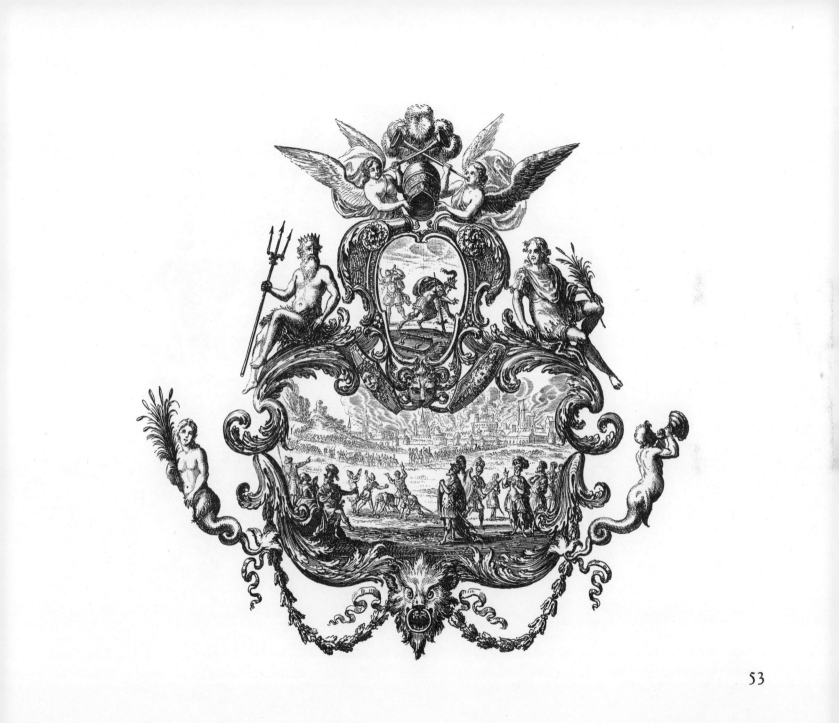

53

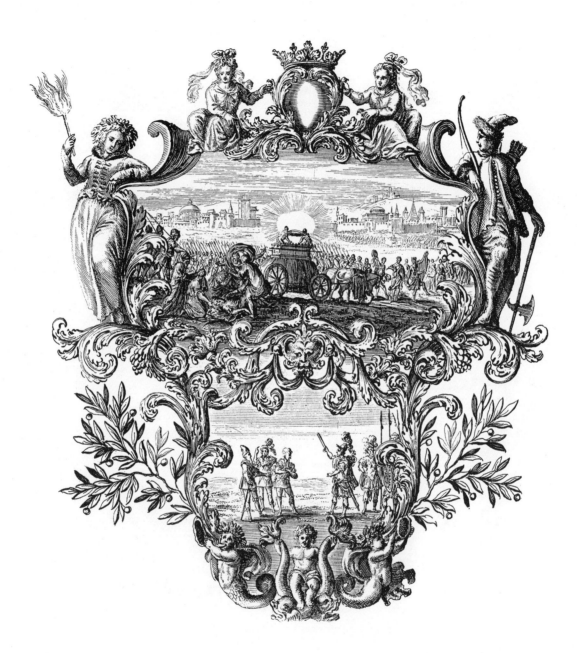

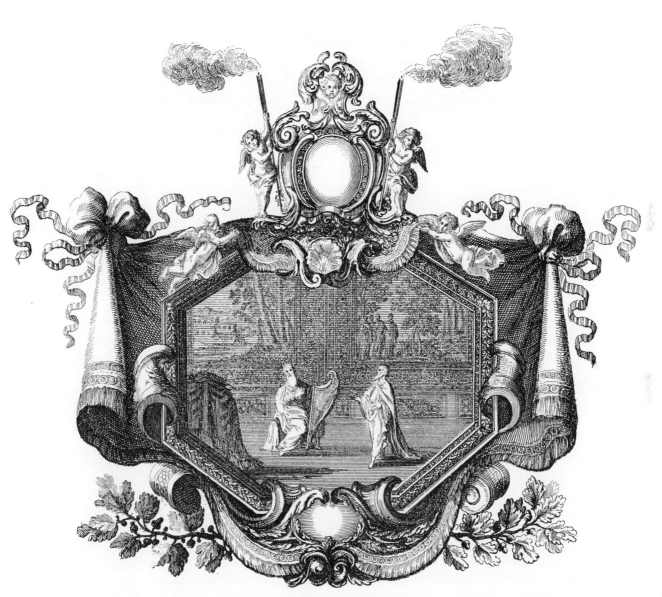

55

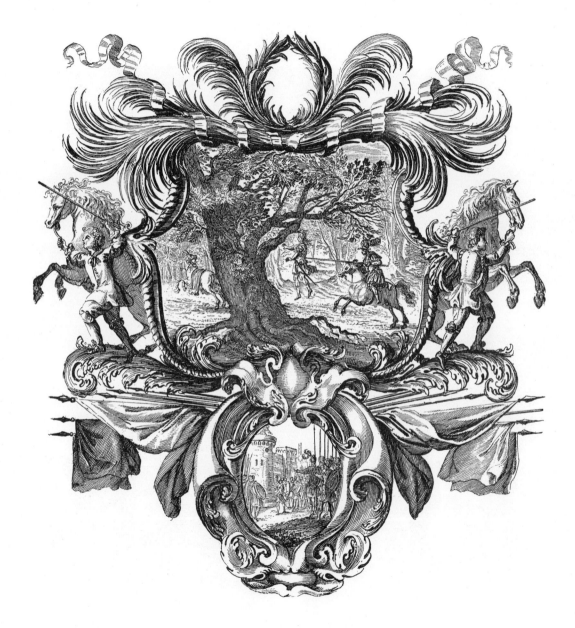

56

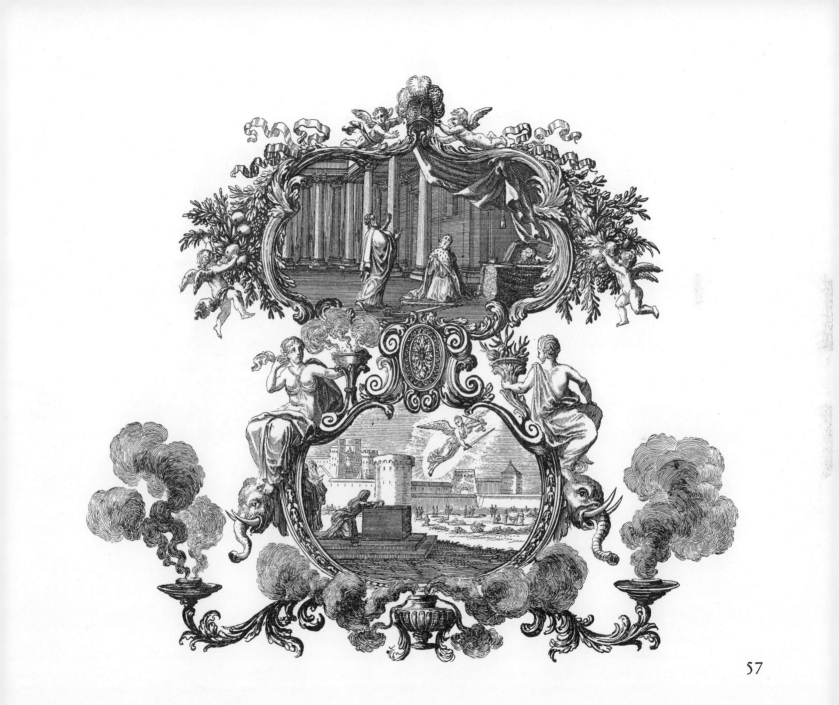

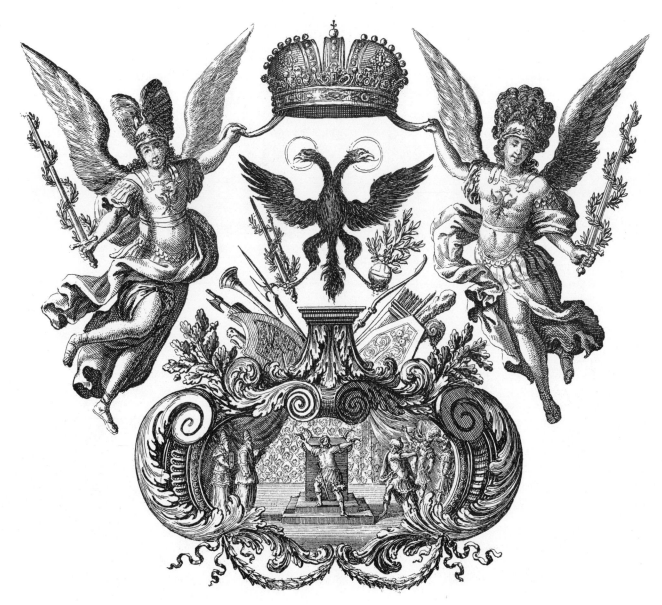

58

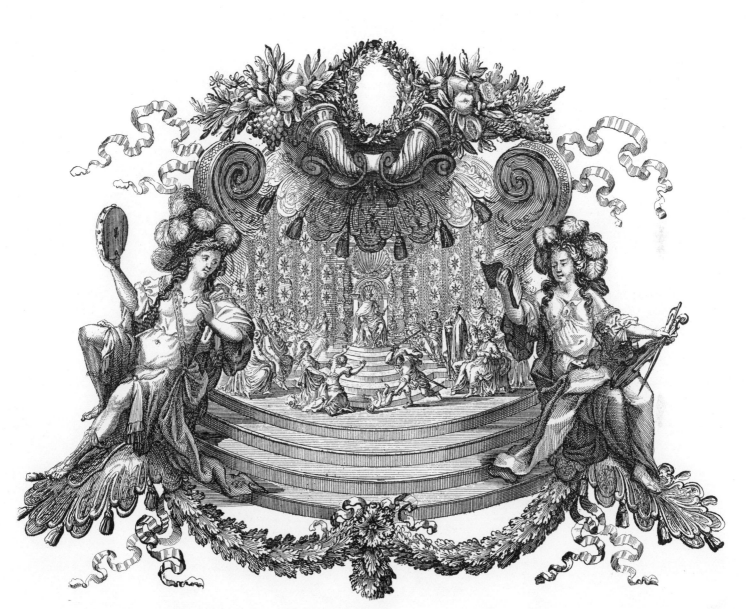

59

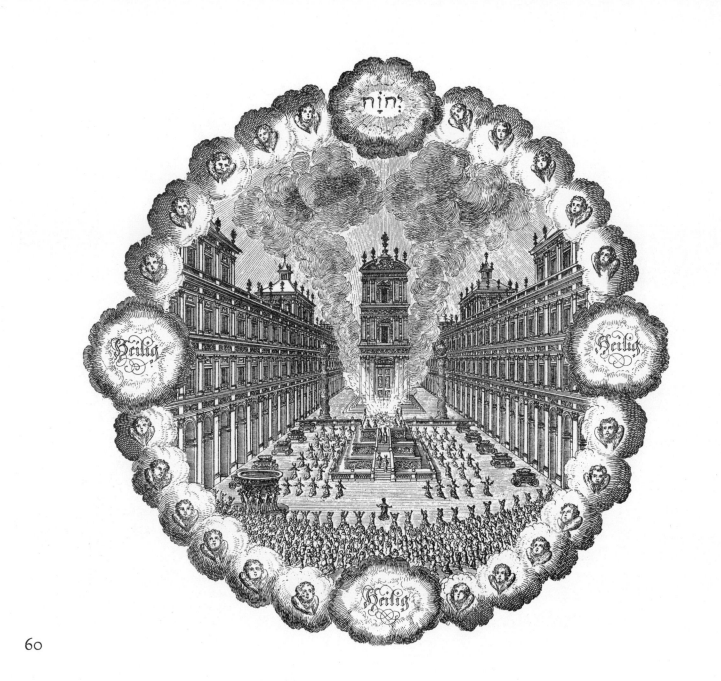

60

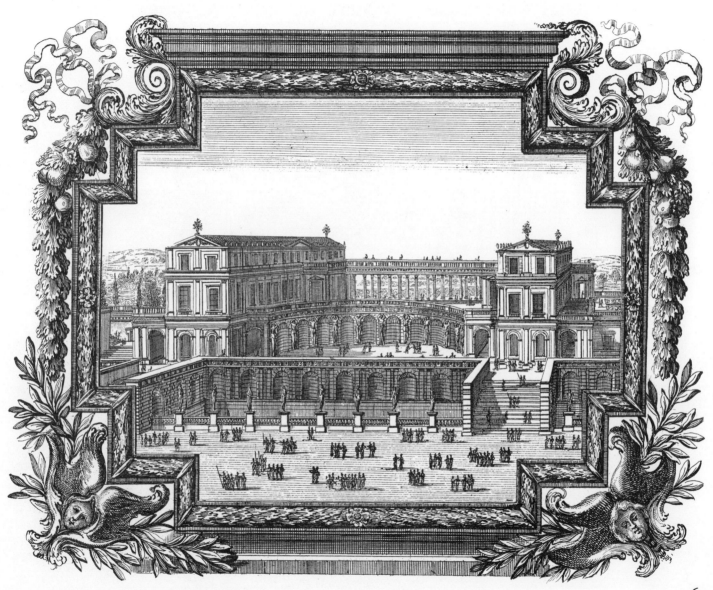

61

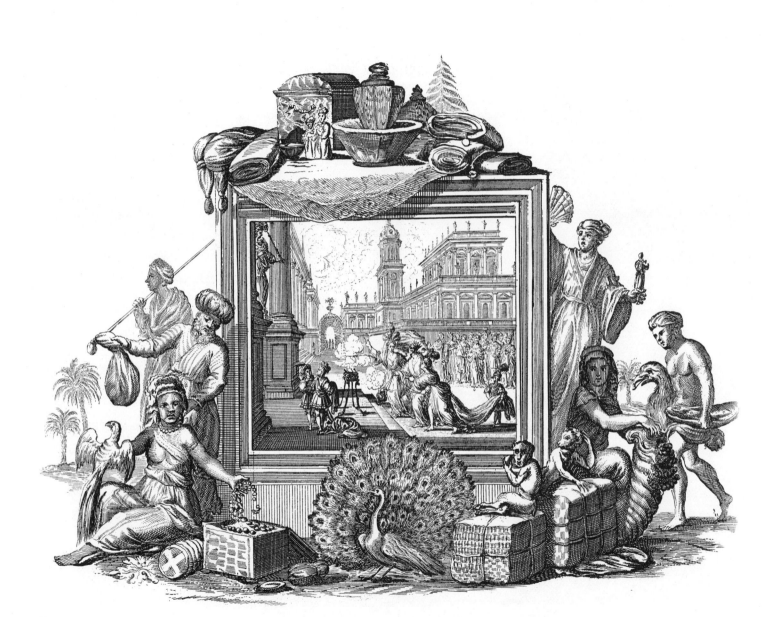

62

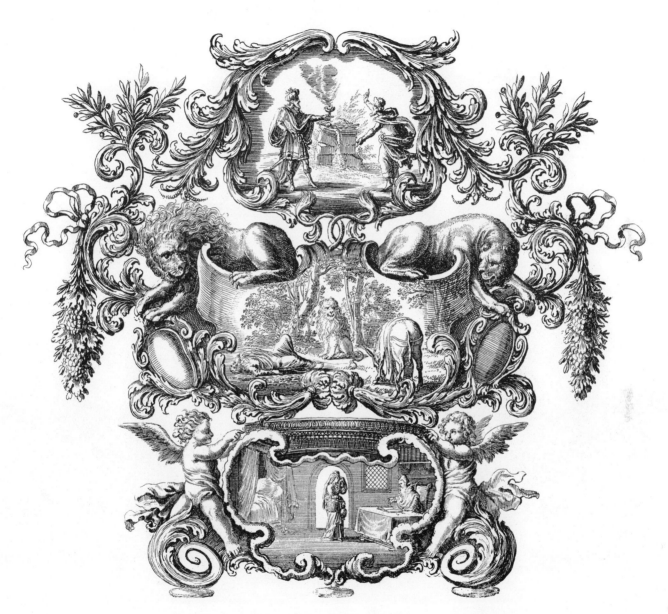

63

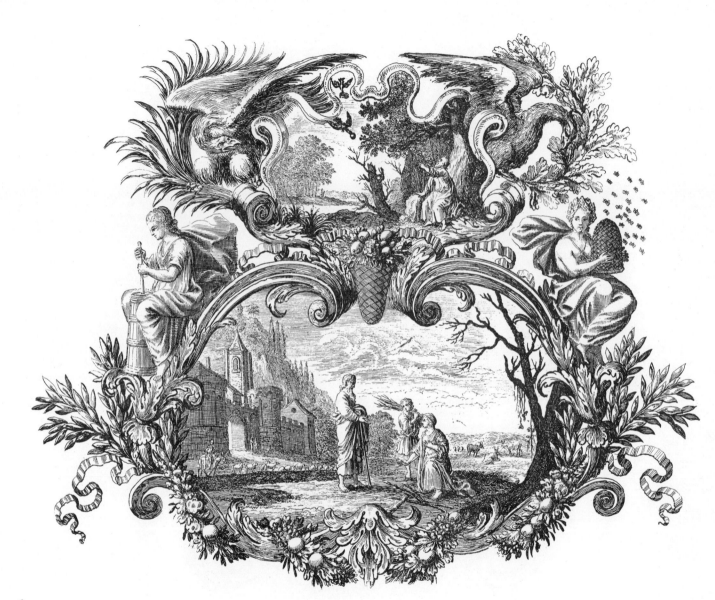

64

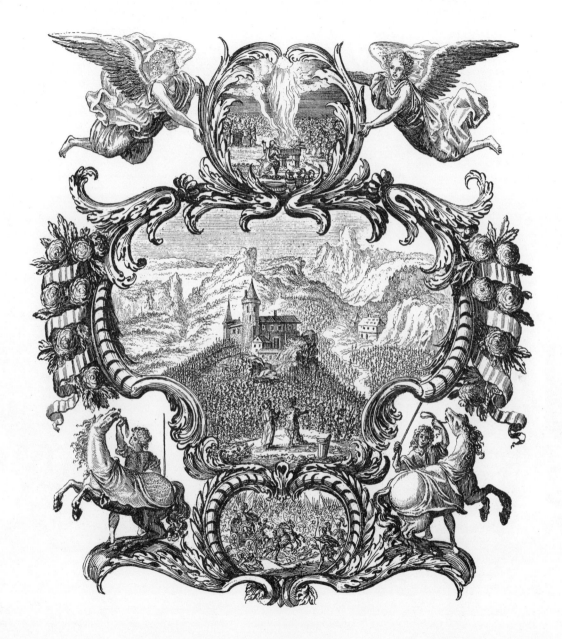

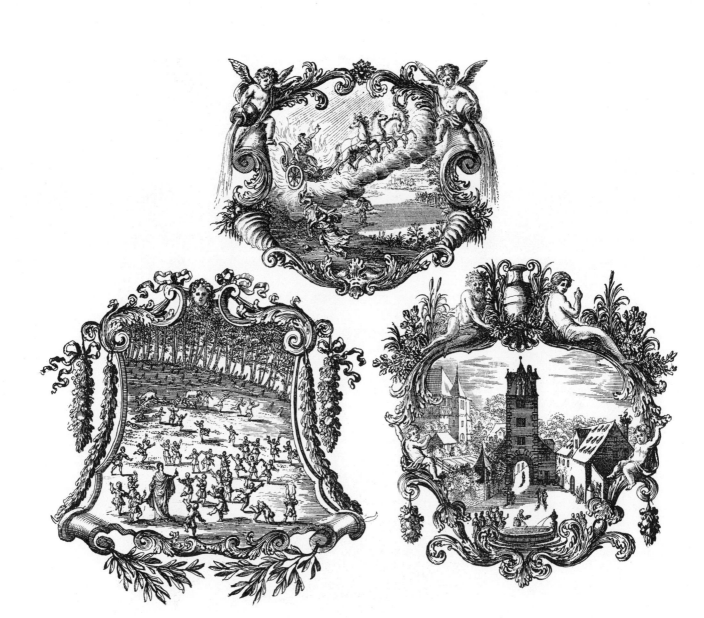

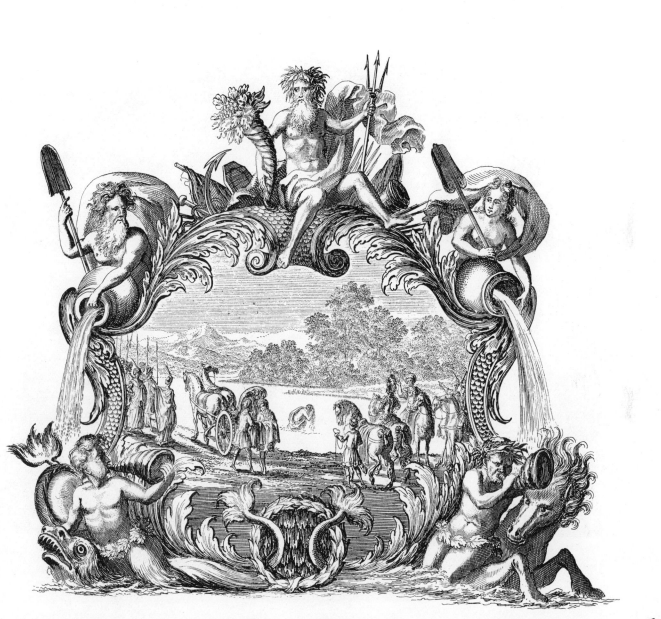

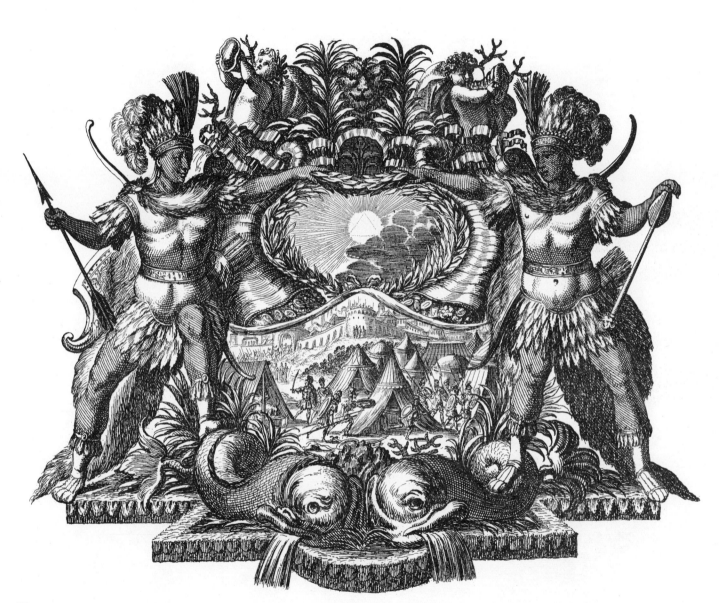

68

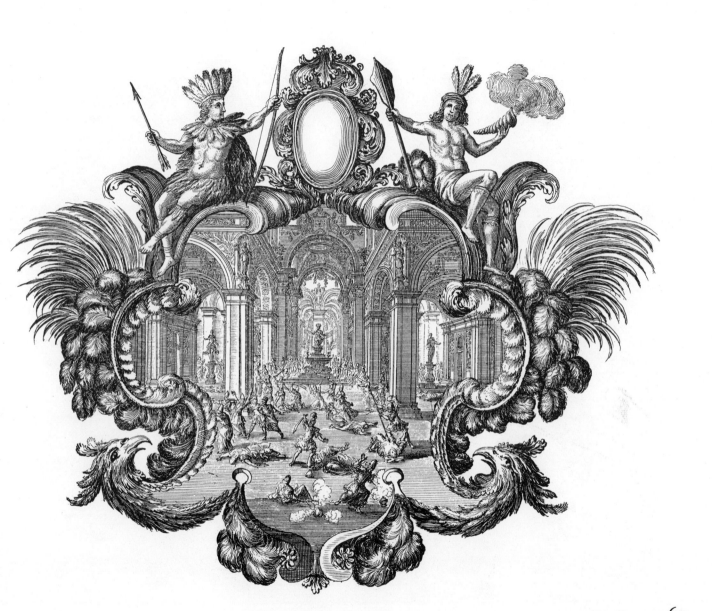

69

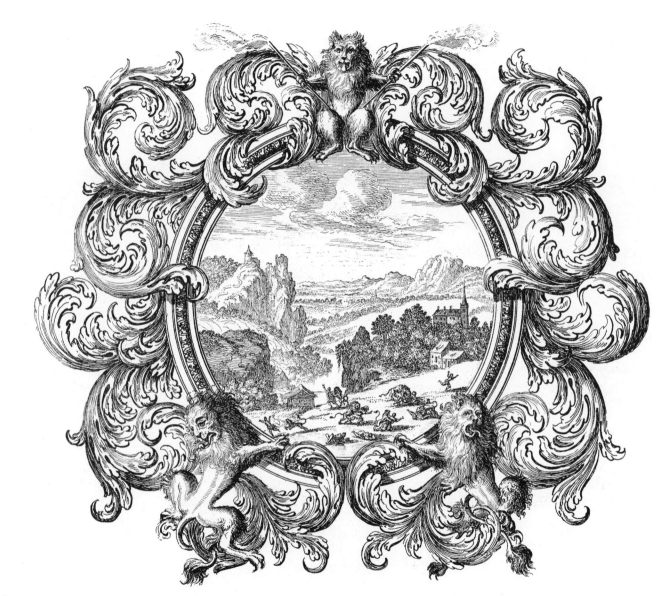

70

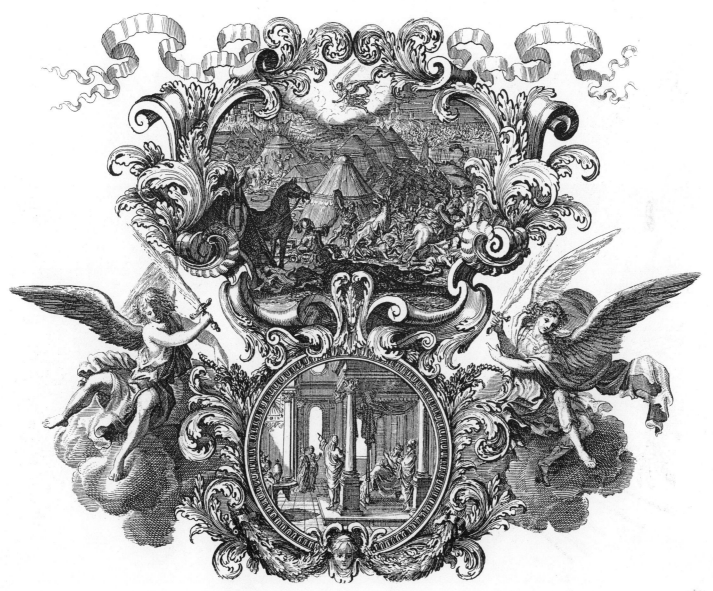

71

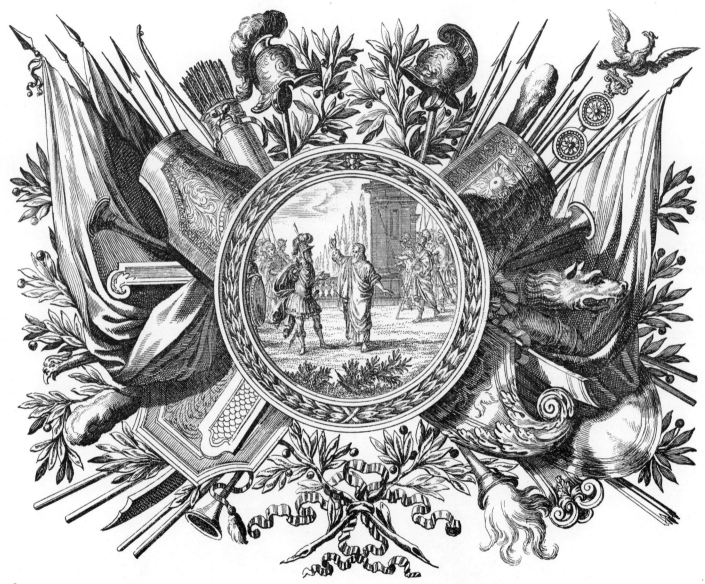

72

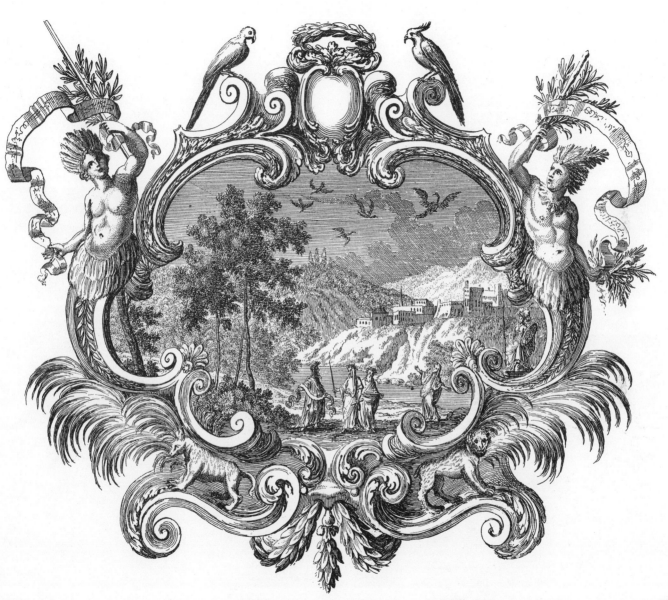

73

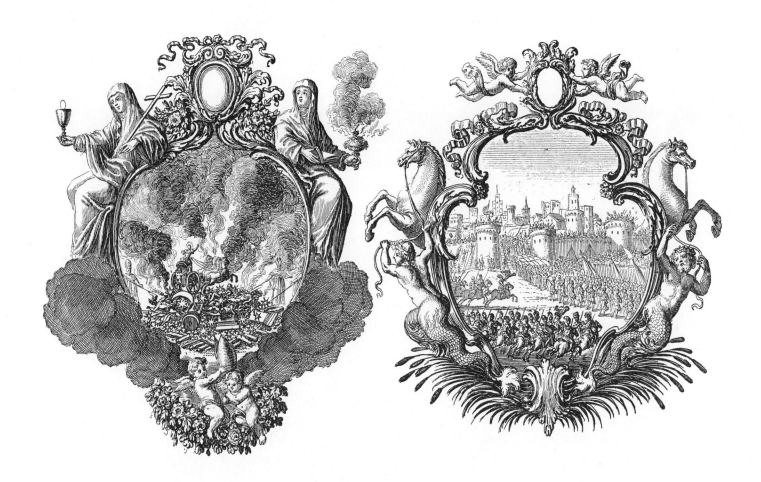

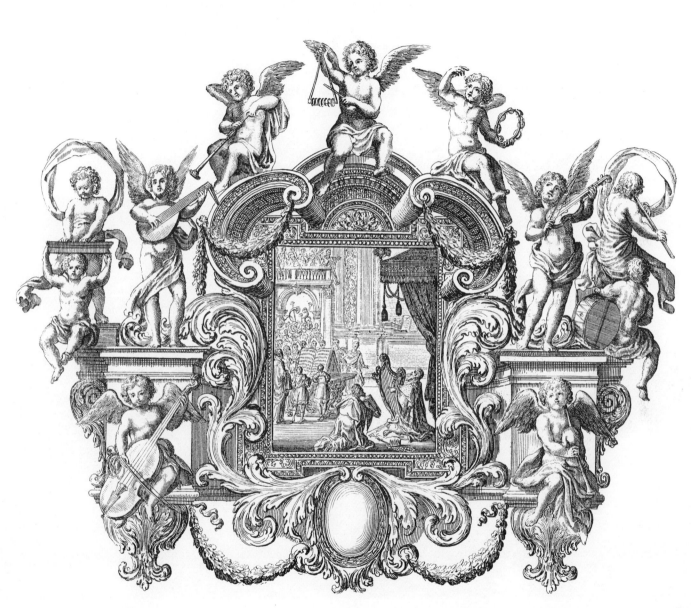

75

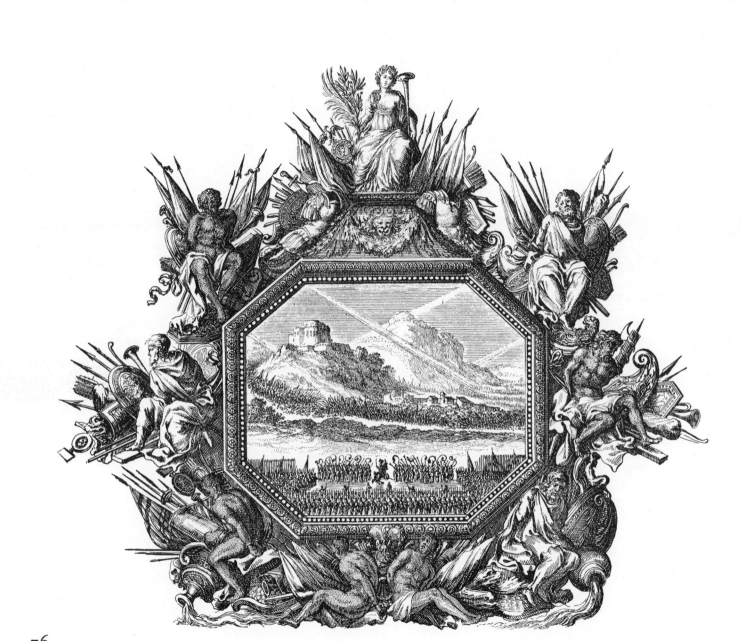

76

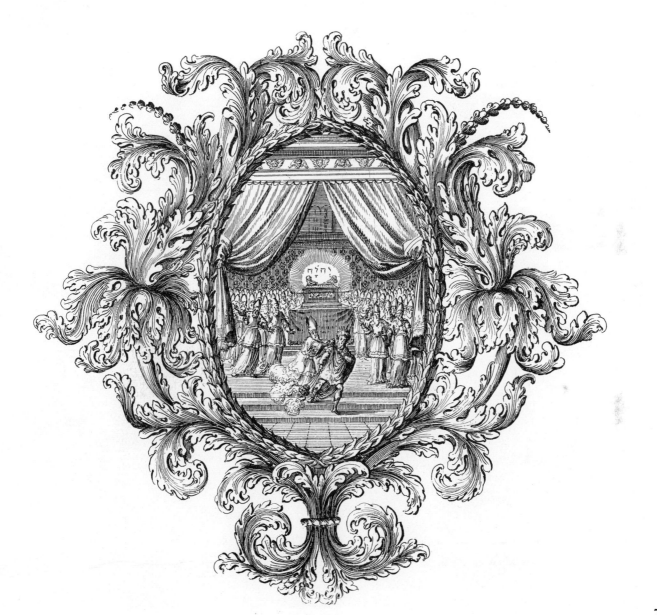

77

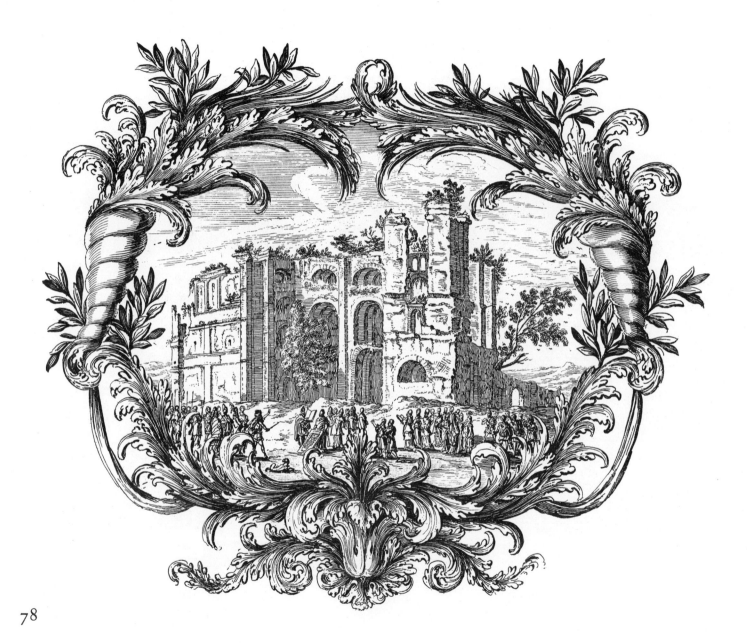

78

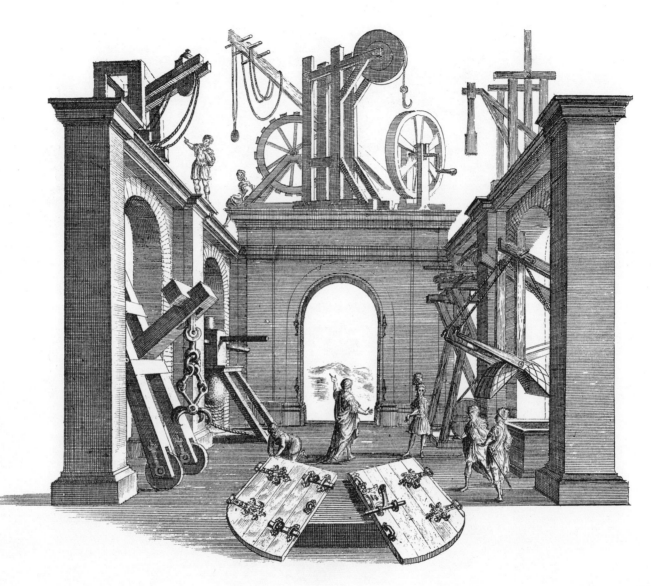

79

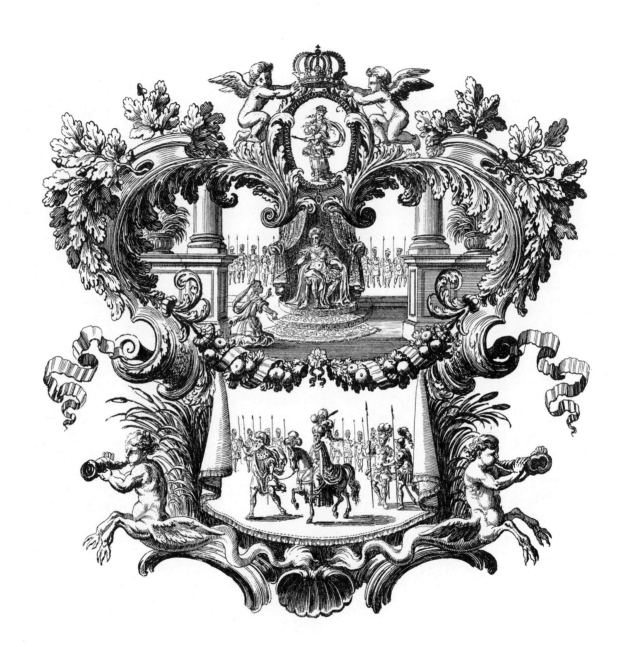

80

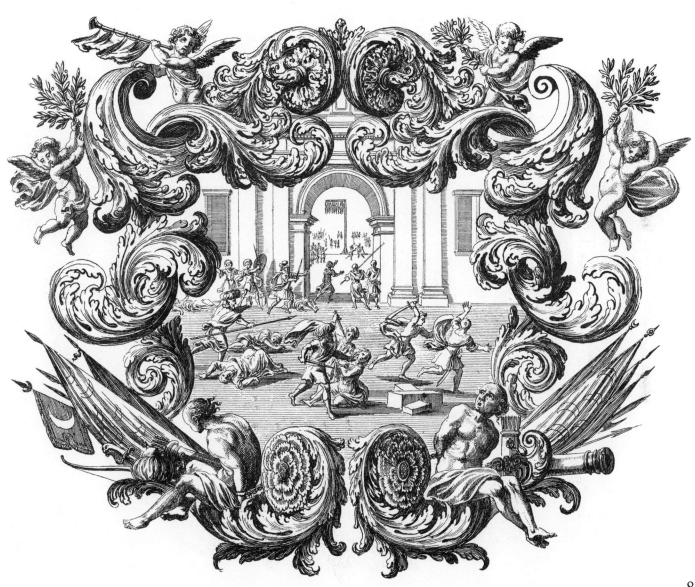

81

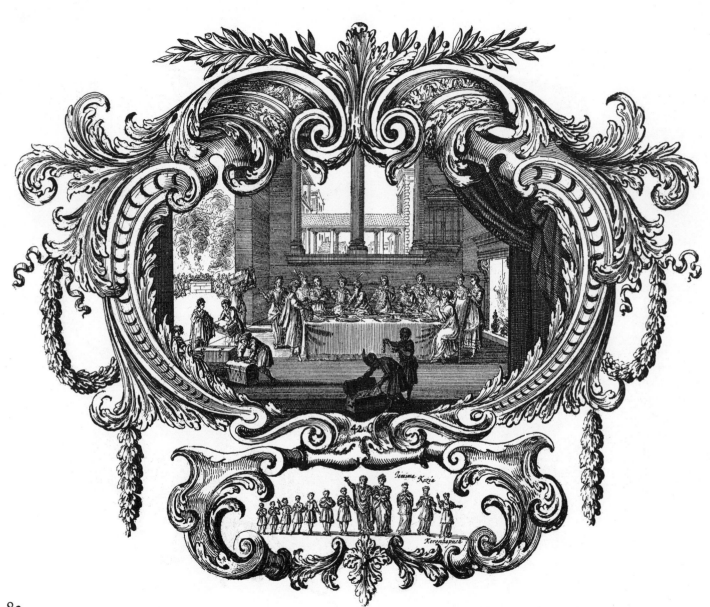

Ieſſius Kozie

Kerenhapuch

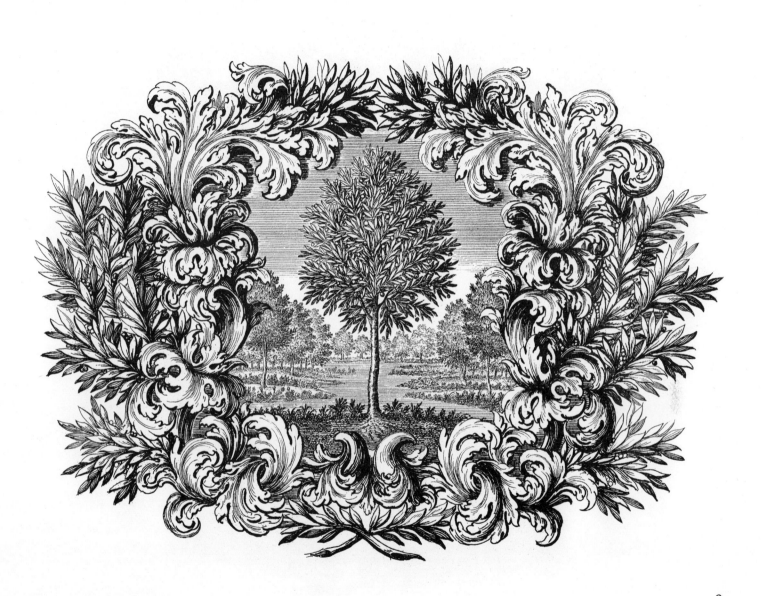

83

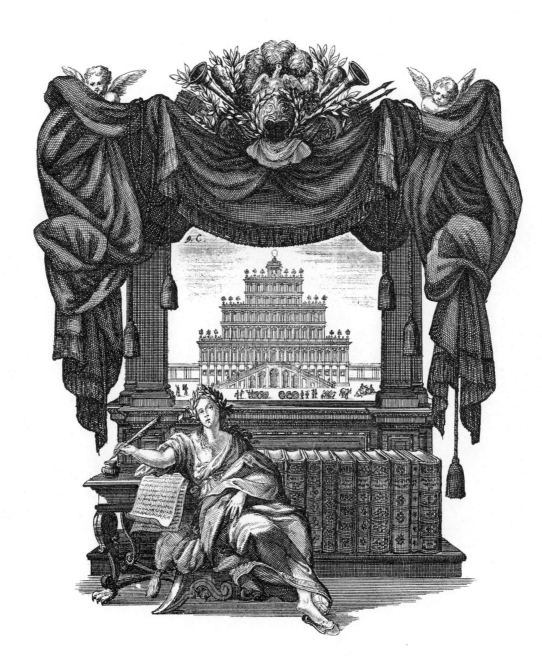

84

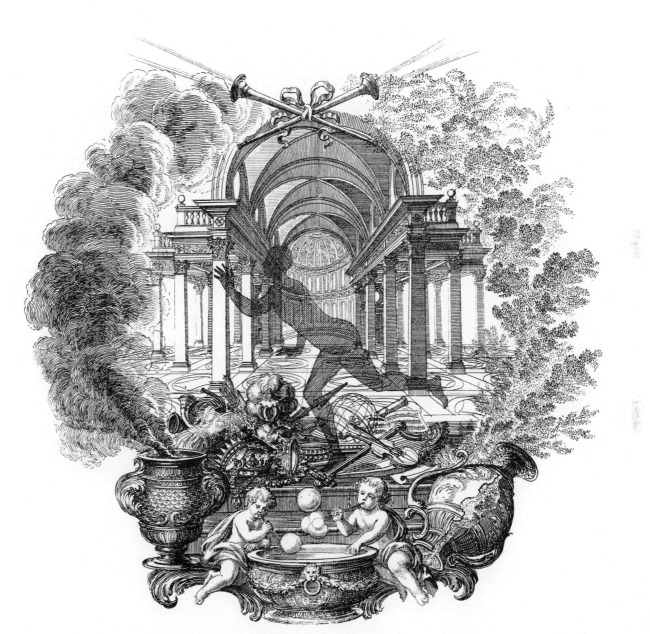

85

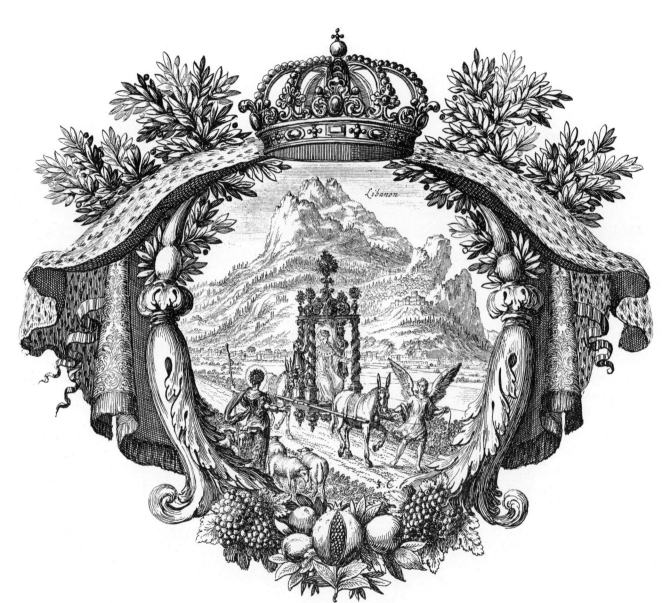

Libanon

86

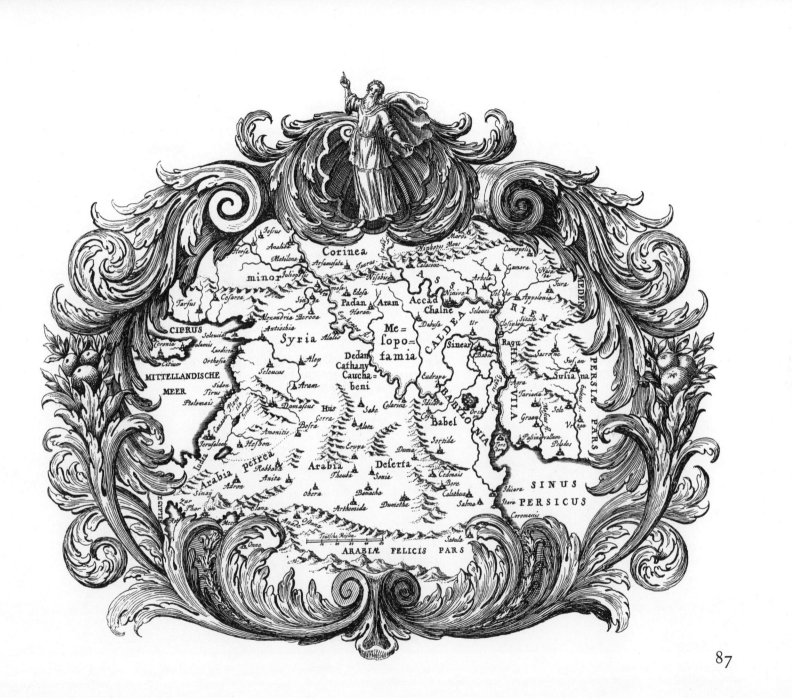

Iefus
Analib
Horfe
Metilene
Iuliopolis
minor
Tarfus
Cesarea
CIPRUS
Seleucia
Ceronia
Salamis
Laodicea
Citium
Orthofia
MITTELLANDISCHE
Sidon
MEER
Tirus
Ptolomais

Corinea
Arfamofata
Taurus
Nifibies
Edefa
Padan
Aram
Haron
Antiochia
Syria
Alalis
Alep
Dedan
Cathany
Cauchabeni

Me=
fopo=
famia

Seleucus
Aram
Damafcus
Hus
Getra
Sabe
Colarina
Bofra
Alata
Amonitis
Babel
Jordan
Jerufalem
Hefbon
Arabia petrea
Rabbath
Anita
Sinay
Adron
Thor
Iona
Obera
Thauba
Sonia
Red Met
Onne
Anade
Obana
Teutfche Meylen

ARABIÆ FELICIS PARS

Ninbites Mons
Mardi
Calaino
Camogelis
Ninive
Arbela
Sura
Accad
Chalne
Seleucia
RIEN
Dabufa
Ur
Cefiphon
CALDEA
Ragu
Sinear
Babel
Eudrapa
Idicara
Ortu
BABYLONIA
Sortida
Erupa
Dumia
Cedmais
Arabia
Deferta
Bore
Calatkua
Benacha
Dumetha
Salma
Arthemida
Coromanis

ASS
Itl tbe
Appolonia
Nifa
Ur
MEDIA
PERSIÆ PARS
Agra
Sufiana
Tariada
Sele
Vr
Graon
Paffiniualum
Pelobes

SINUS
PERSICUS

87

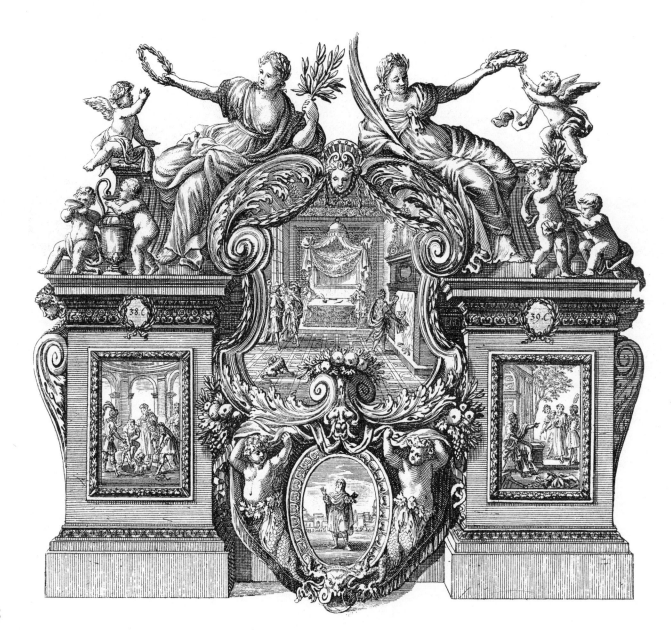

88

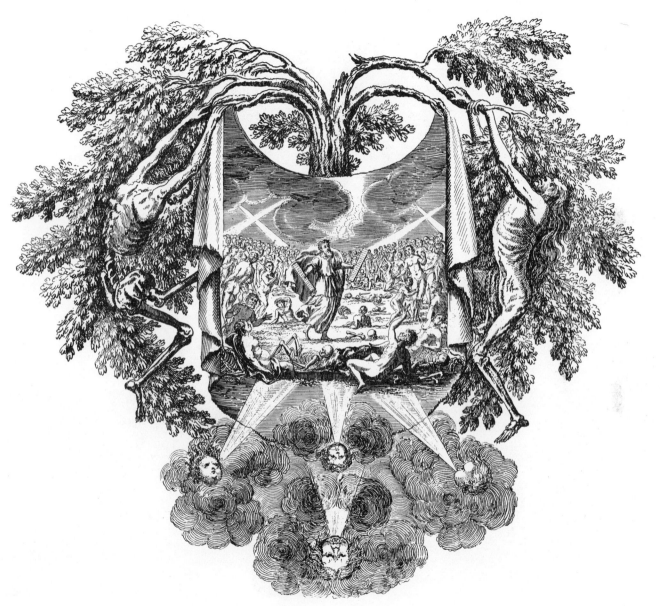

89

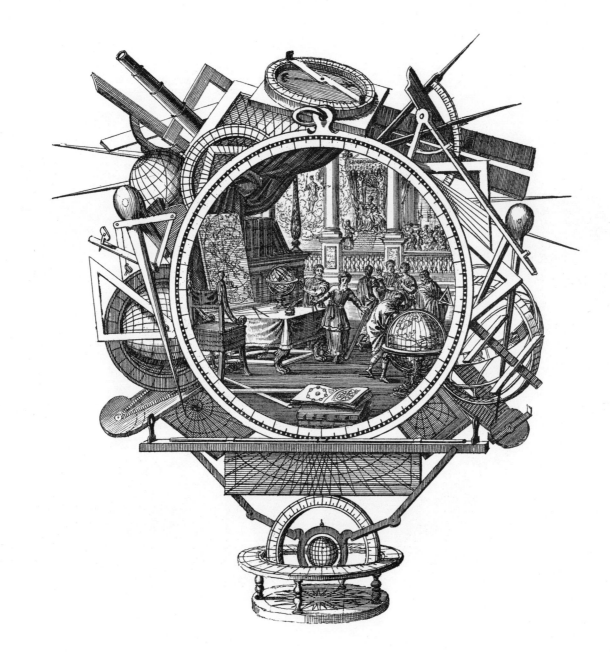

90

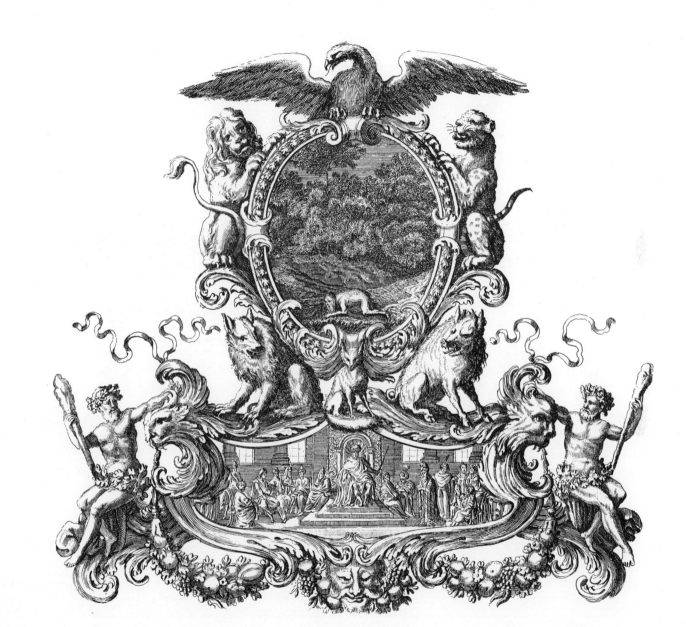

91

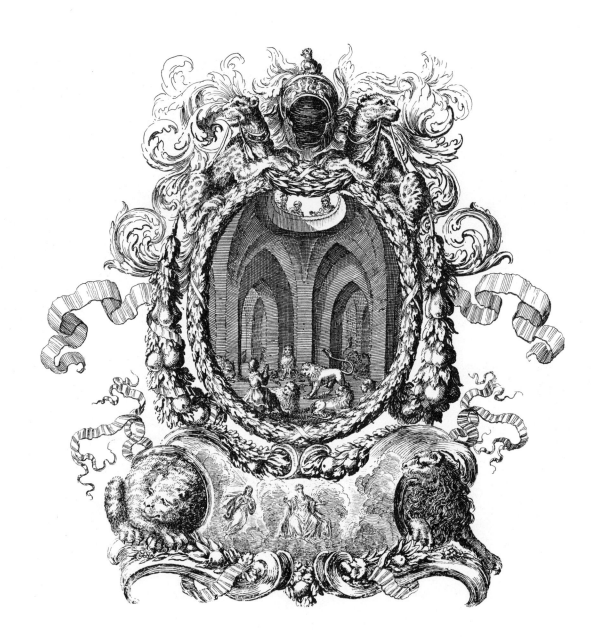

92

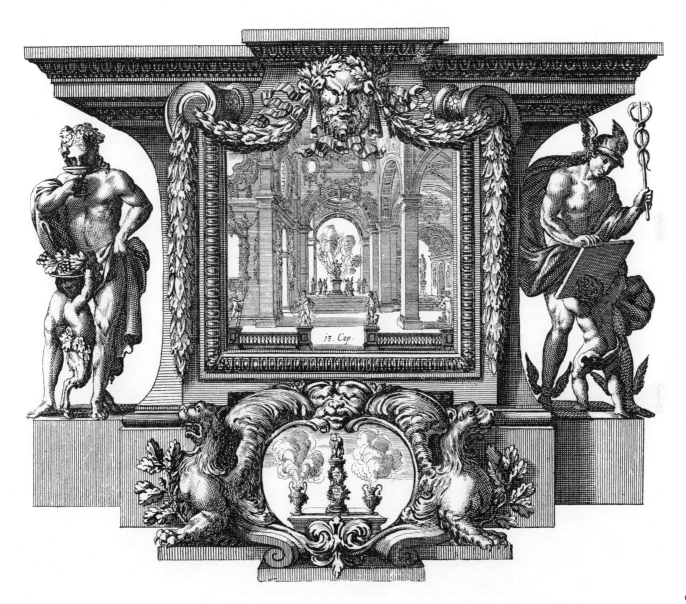

13. Cap.

93

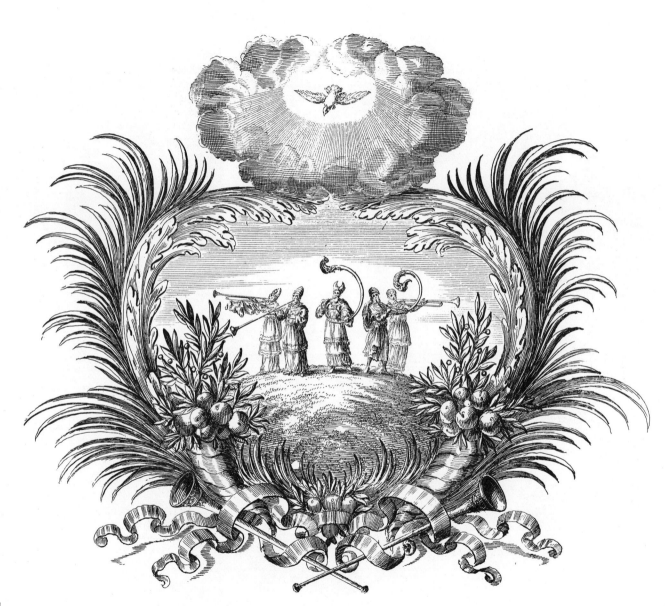

94

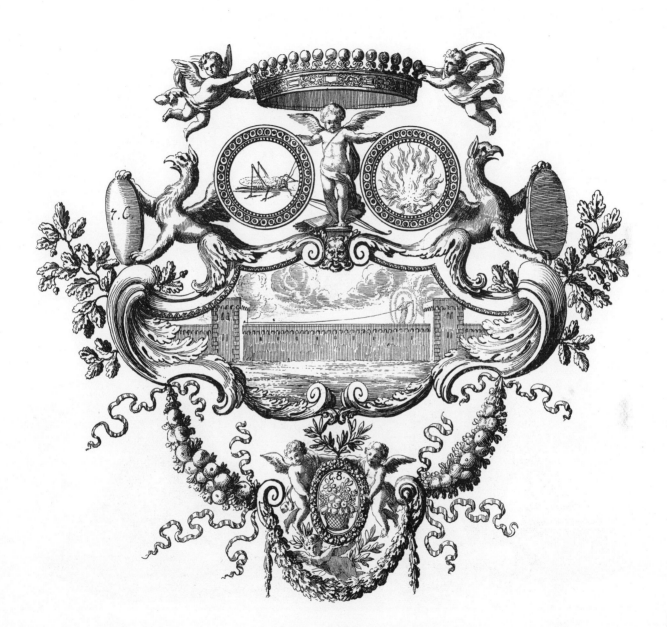

95

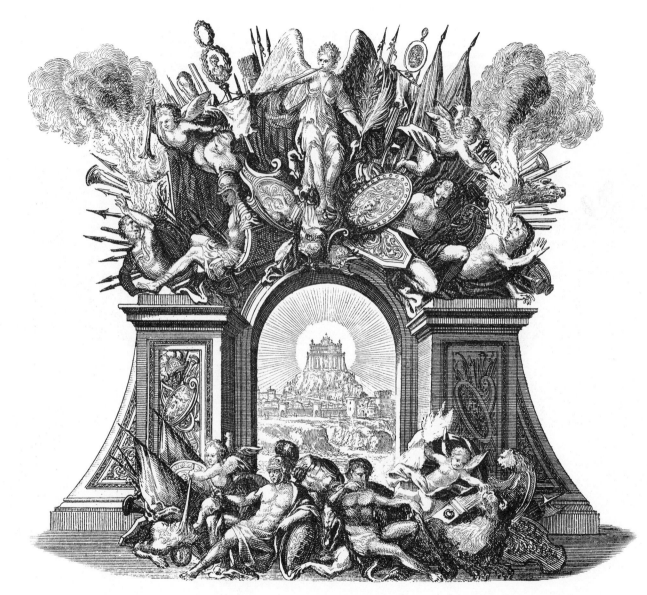

96

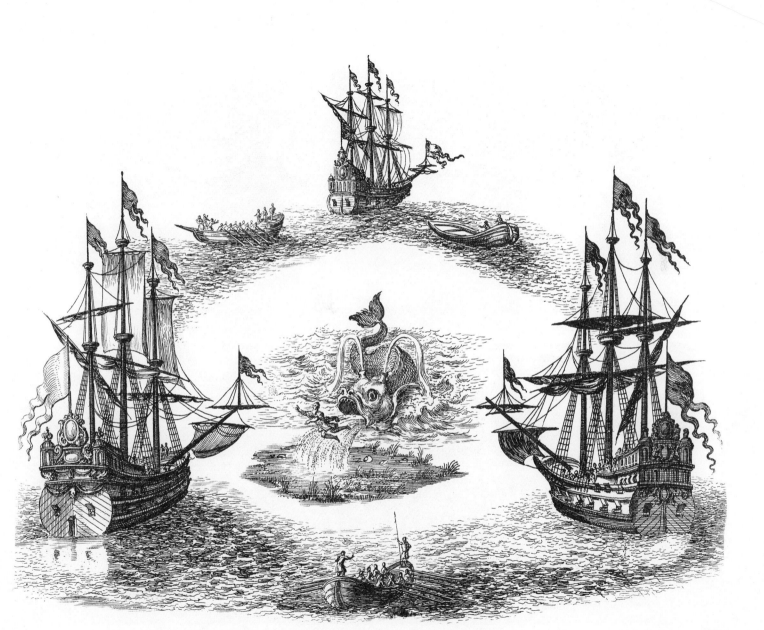

97

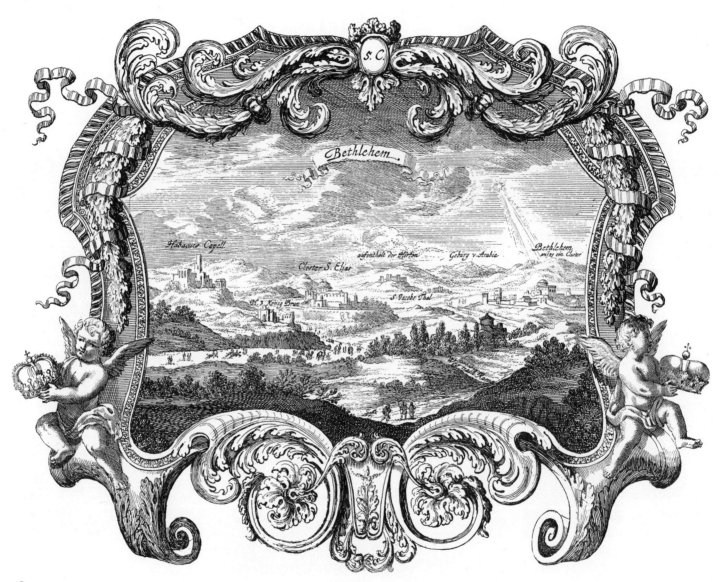

Bethlehem

Habacucs Capell

Closter S. Elias

aufenthalt der Hirten

Gebirg v. Arabia

Bethlehem
anizo ein Closter

H. 3 König Brun

S. Jacobs Thal

98

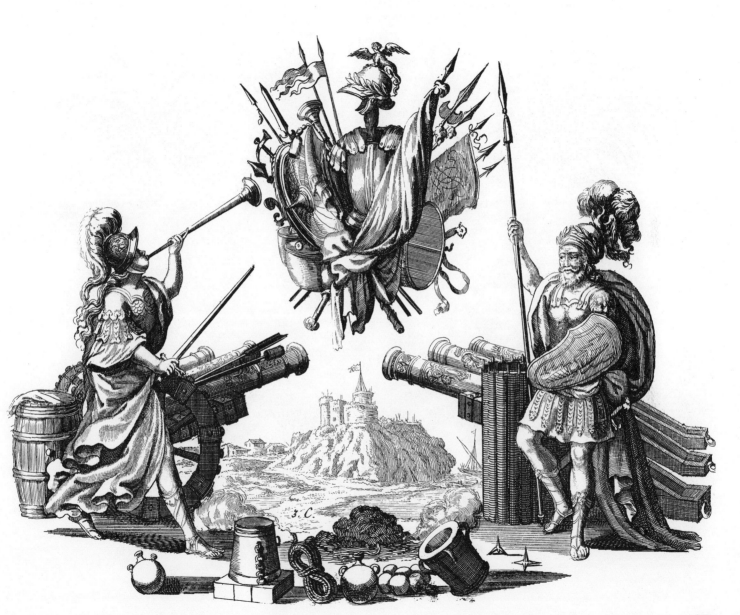

99

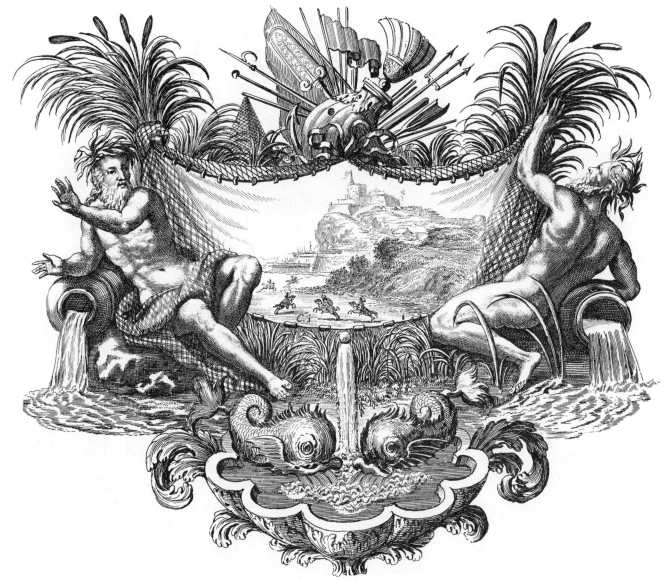

100

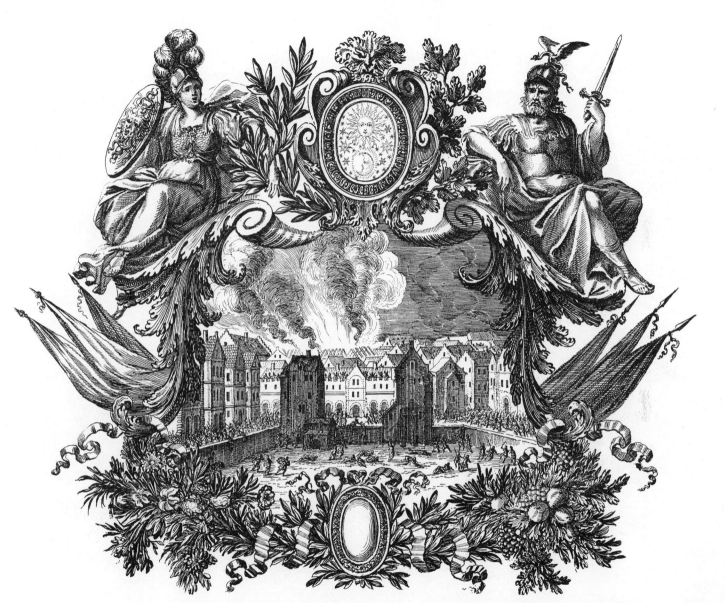

101

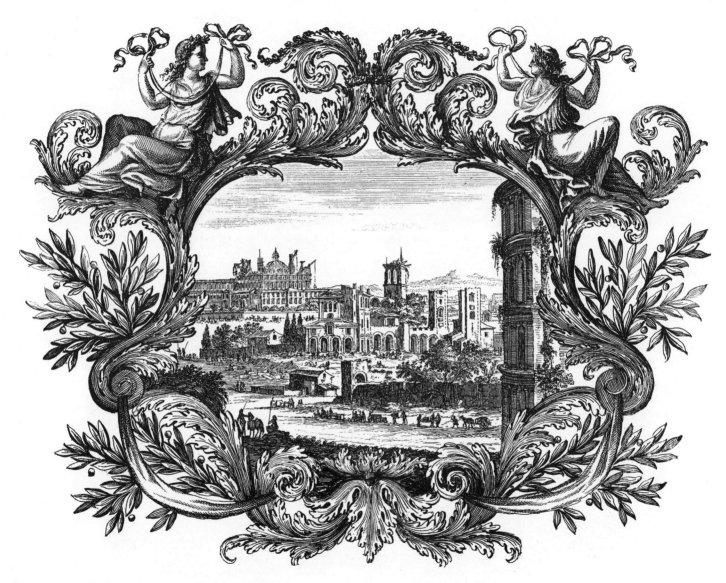

102

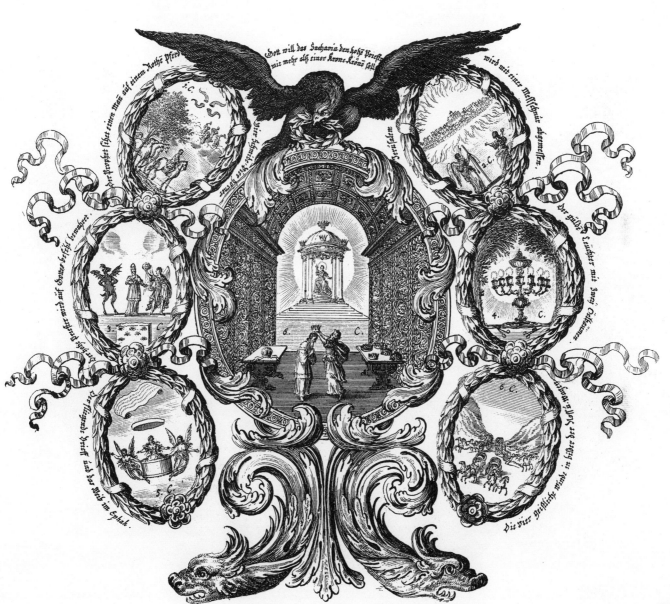

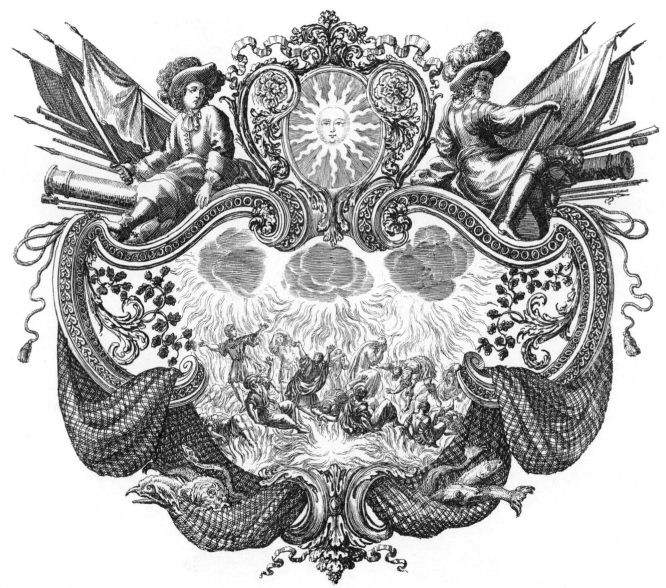

104

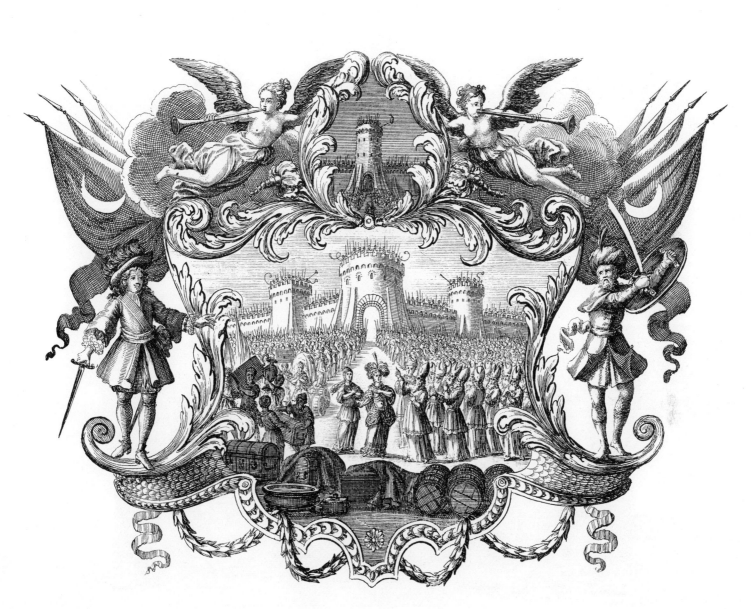

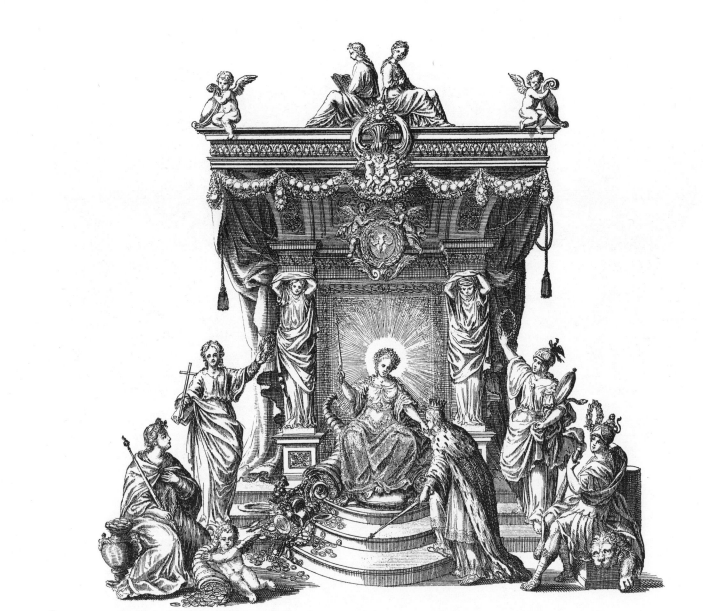

106

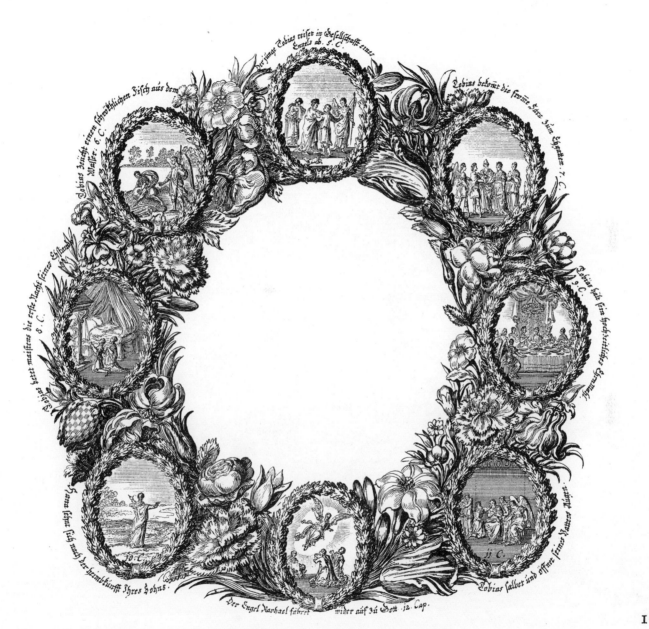

Der junge Tobias reiset in Gesellschafft eines
Engels ab. 5. C.

Tobias fänget einen schröcklichen Fisch aus dem
Wasser. 6. C.

Tobias bekomt die fromme Sara zum Ehgatten. 7. C.

Tobias betet mit seiner die erste Nacht seines Ehstand
8. C.

Tobias hält ein hochzeitliches Gastmahl
9. C.

Sara sehnt sich nach der herumkunfft Ihres Sohns.
10. C.

Der Engel Raphael fahret widder auff zu Gott. 12. Cap.

Tobias salbet und öffnet seines Vatters Augen
11. C.

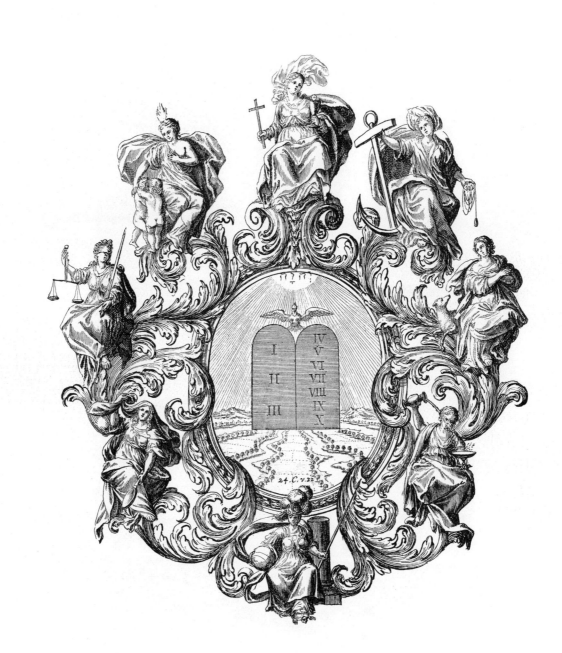

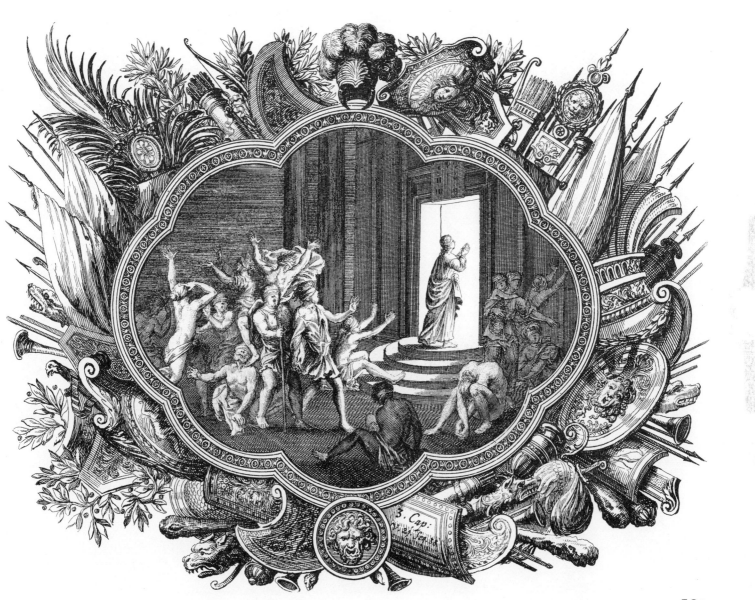

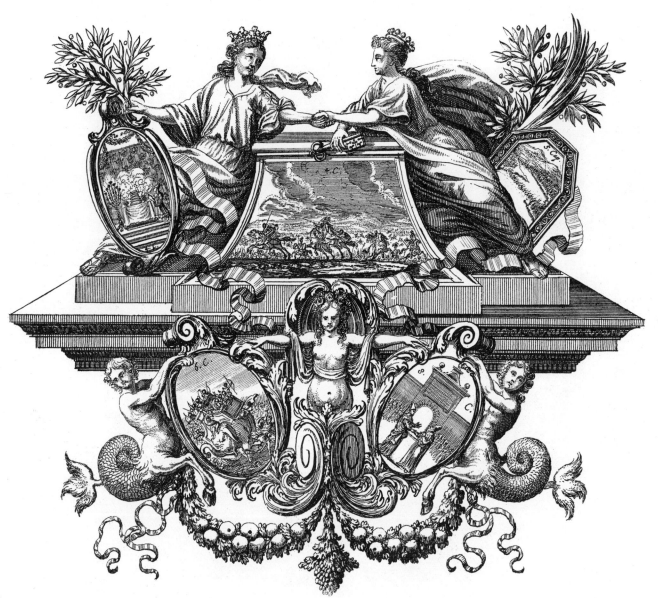

IIO

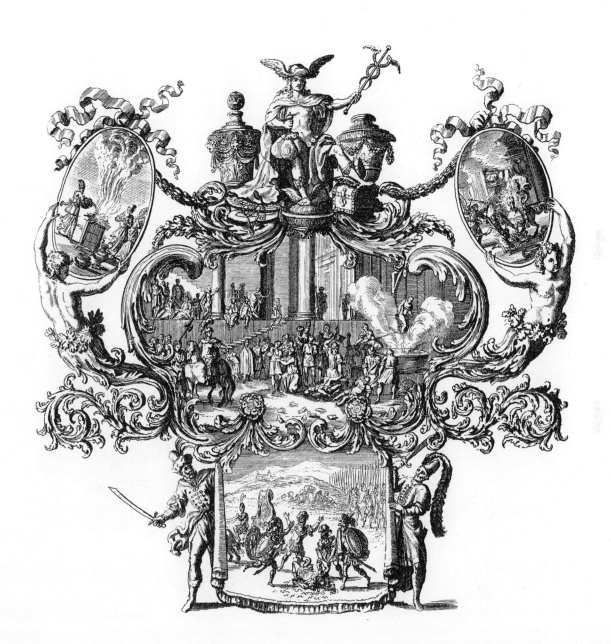

III

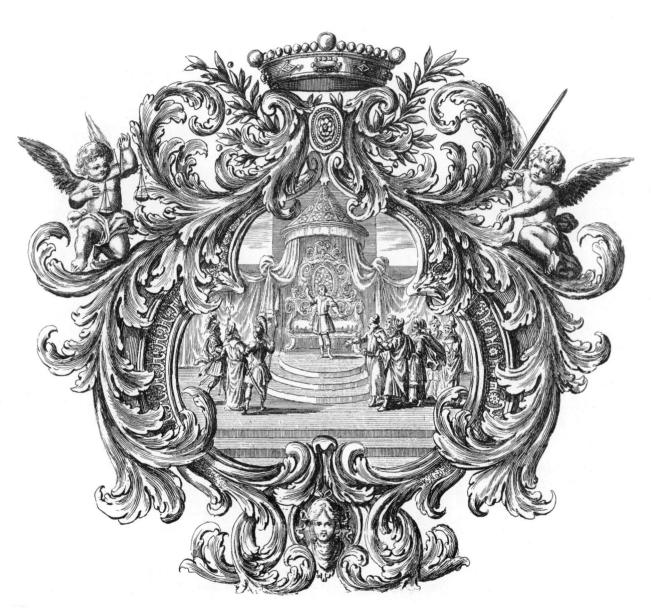

112

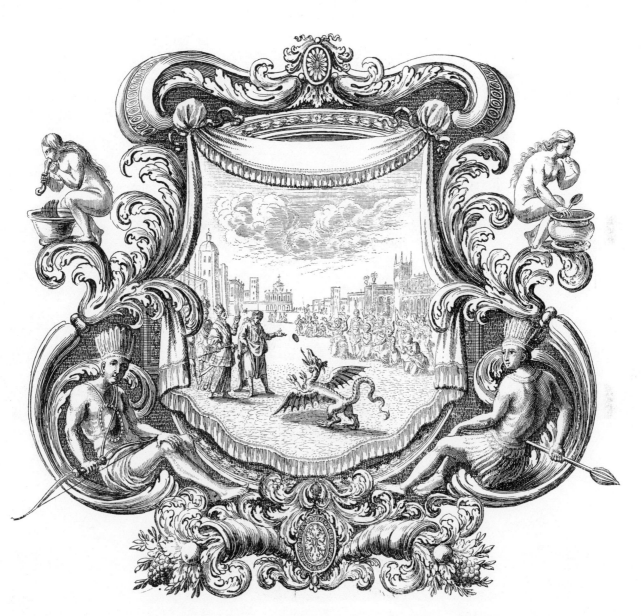

113

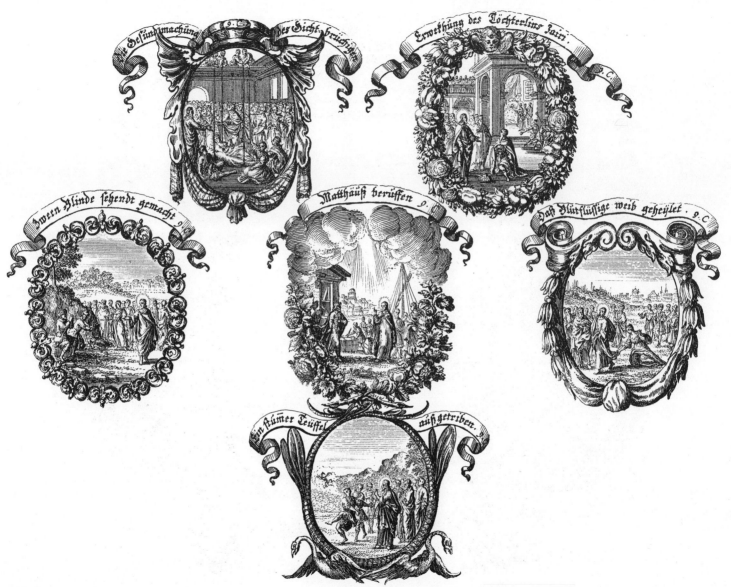

114

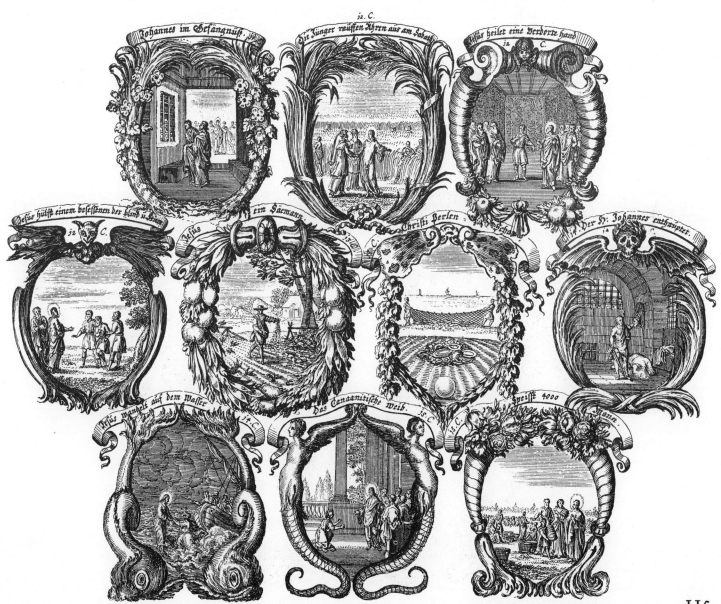

Johannes im Gefängnüß.

12. C.

Die Jünger rauffen Ahren auß am Sabath.

Jesus heilet eine verdorrte hand
12. C.

Jesus hülfft einem besessenen der blind u. stum
12. C.

Jesus ein Säemann.
13. C.

Christi Perlen Schatz

Der H: Johannes enthäuptet.
14. C.

Jesus wandelt auf dem Wasser
14. C.

Das Canaanitische Weib.
15. C.

15. C. Jesus speißt 4000
Mann.

115

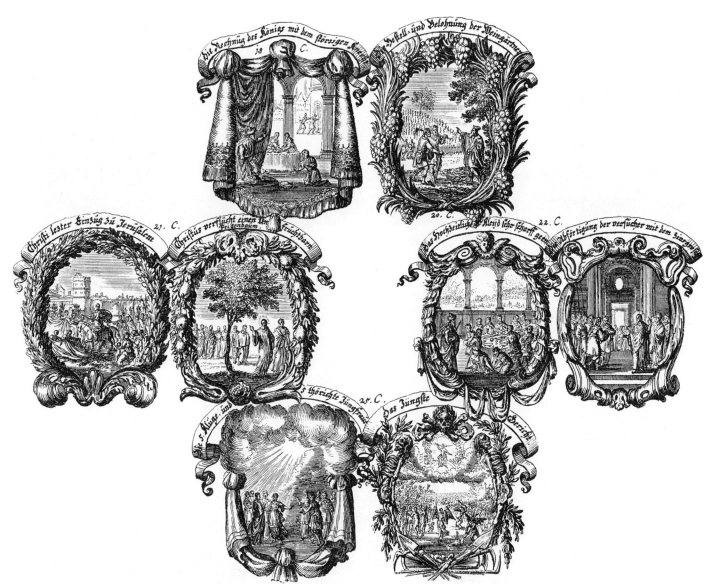

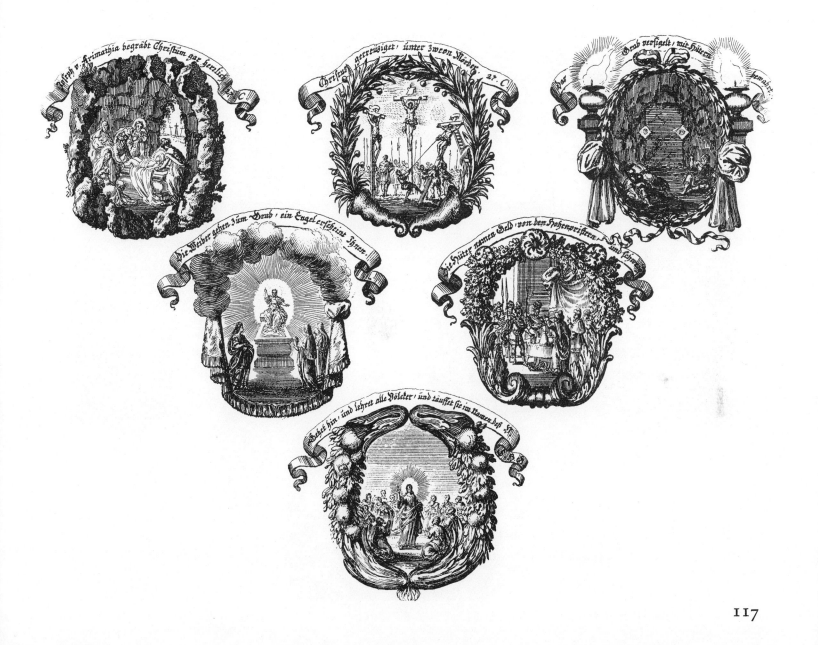

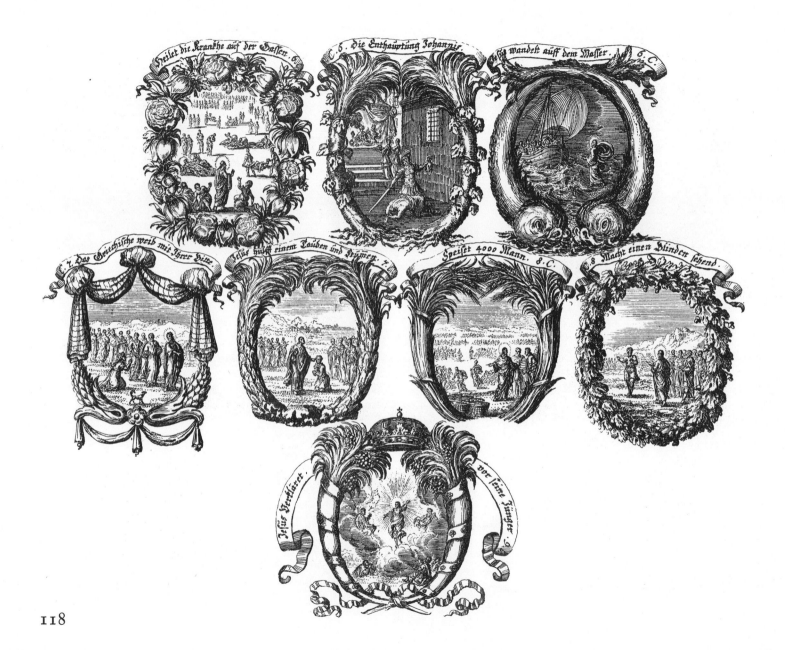

118

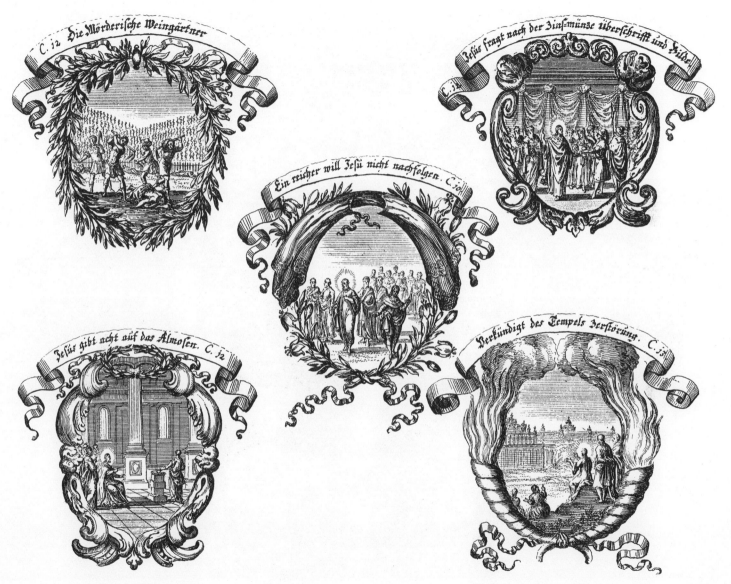

C. 12 Die Mörderische Weingärtner

Jesus fragt nach der Zins-münze überschrifft und Bilde.

Ein reicher will Jesu nicht nachfolgen. C. 10

Jesus gibt acht auf das Almosen. C. 12

Verkündigt des Tempels Zerstörüng. C. 13

119

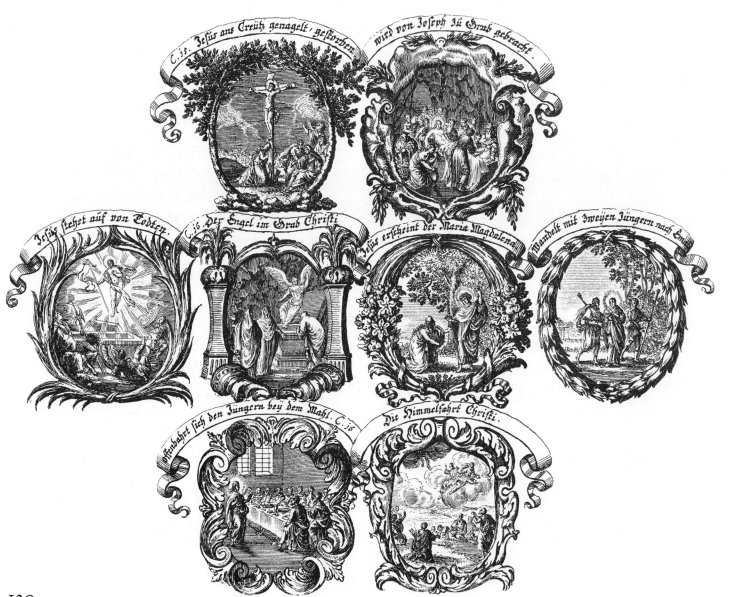

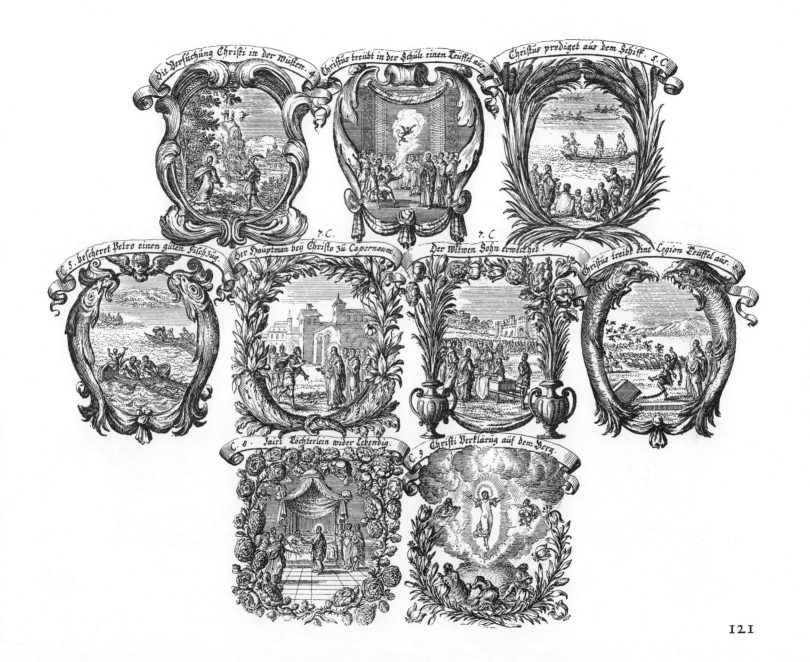

Die Versuchung Christi in der Wüsten. 4.

Christus treibt in der Schüle einen Teüffel aus.

Christus prediget aus dem Schiff. 5. C.

5. bescheret Petro einen guten Fischzug.

Der Hauptman bey Christo zu Capernaum 7. C.

Der Witwen Sohn erwecket. 7. C.

Christus treibt eine Legion Teüffel aus.

C. 8. Jairi Töchterlein wider Lebendig.

Christi Verklärug auf dem Herg. C. 9

121

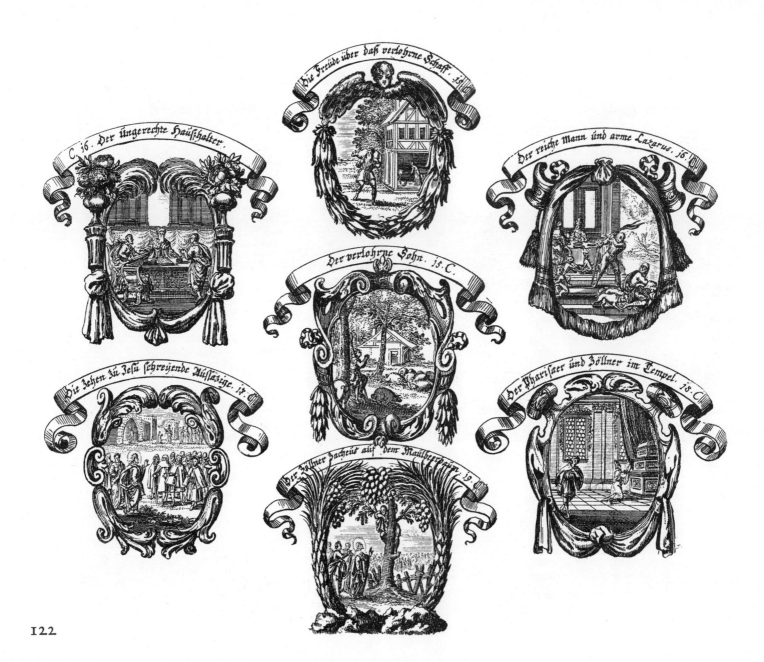

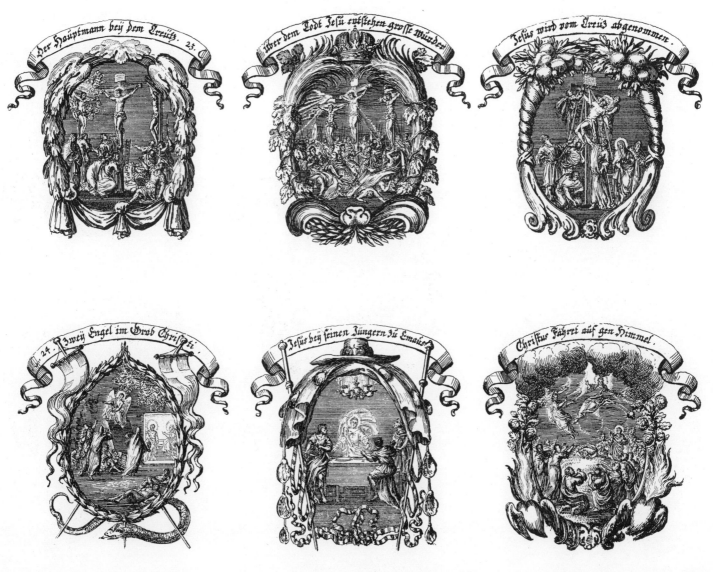

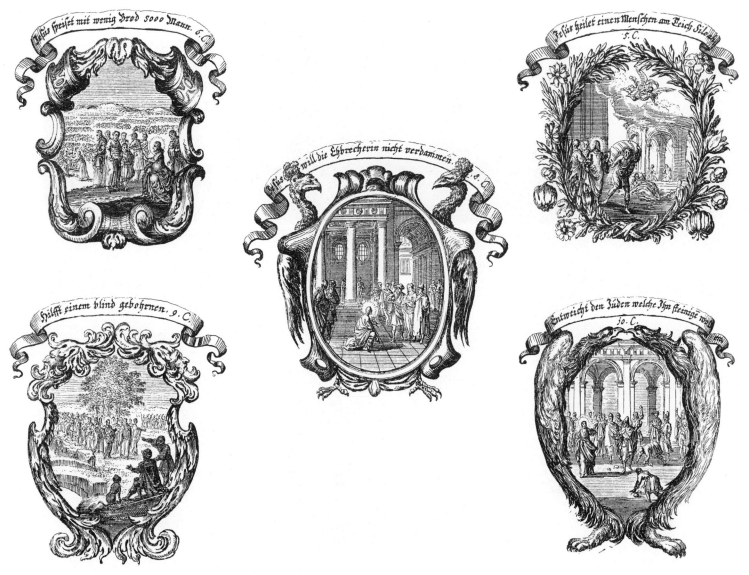

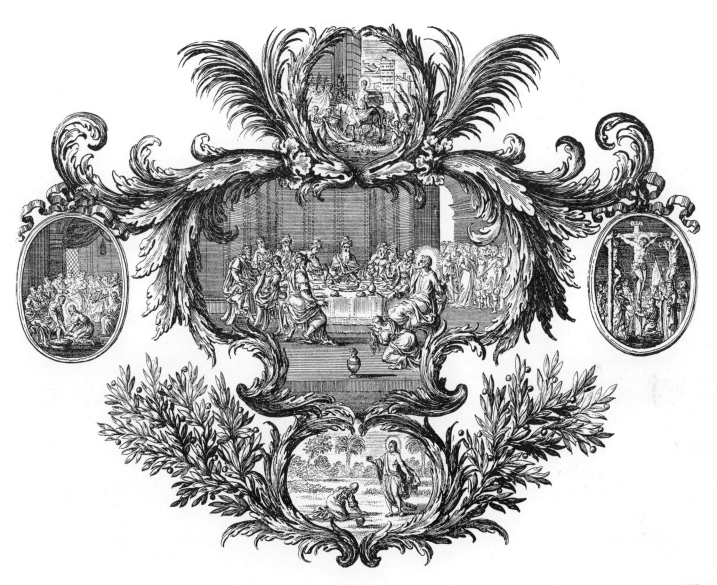

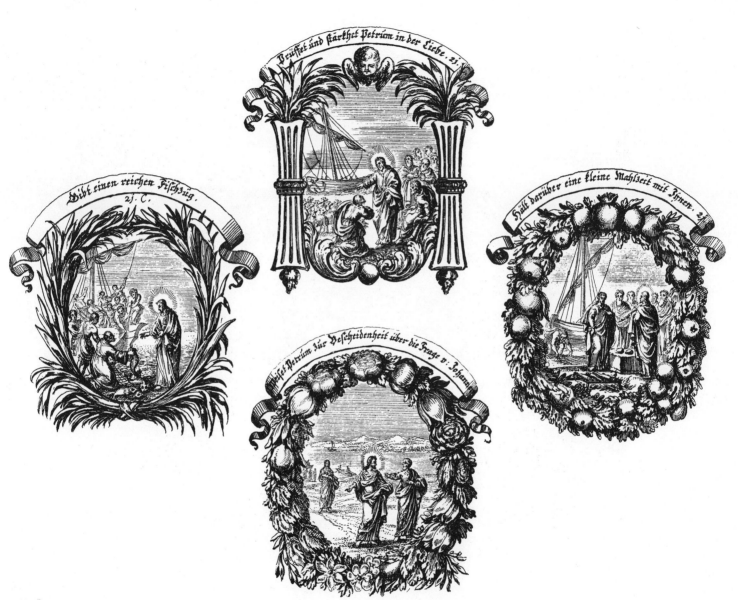

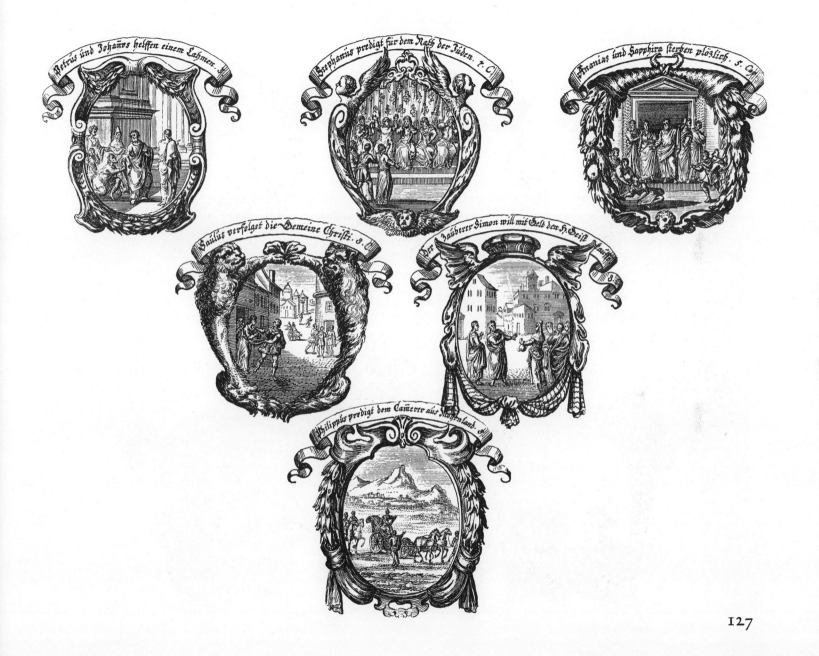

127

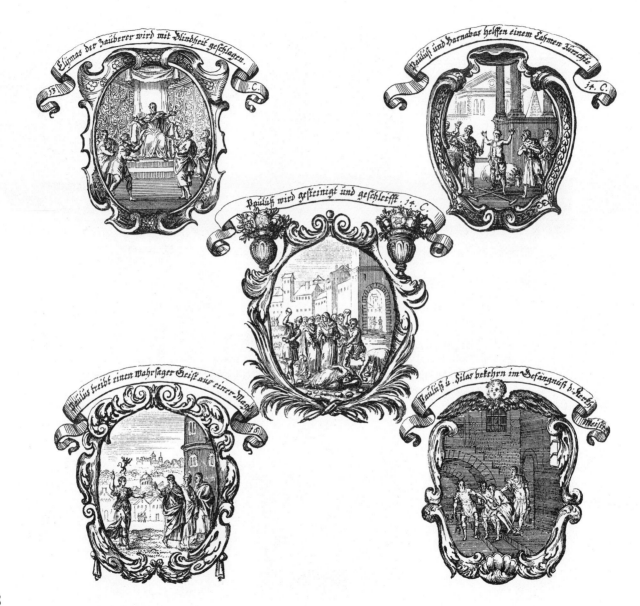

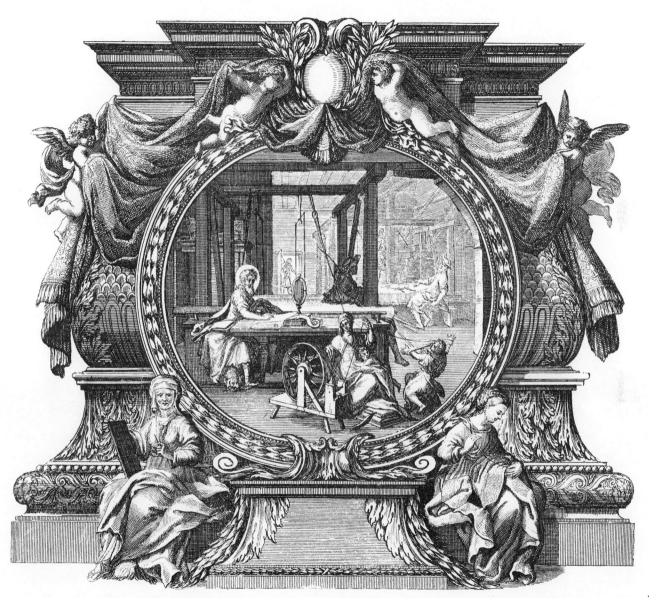

129

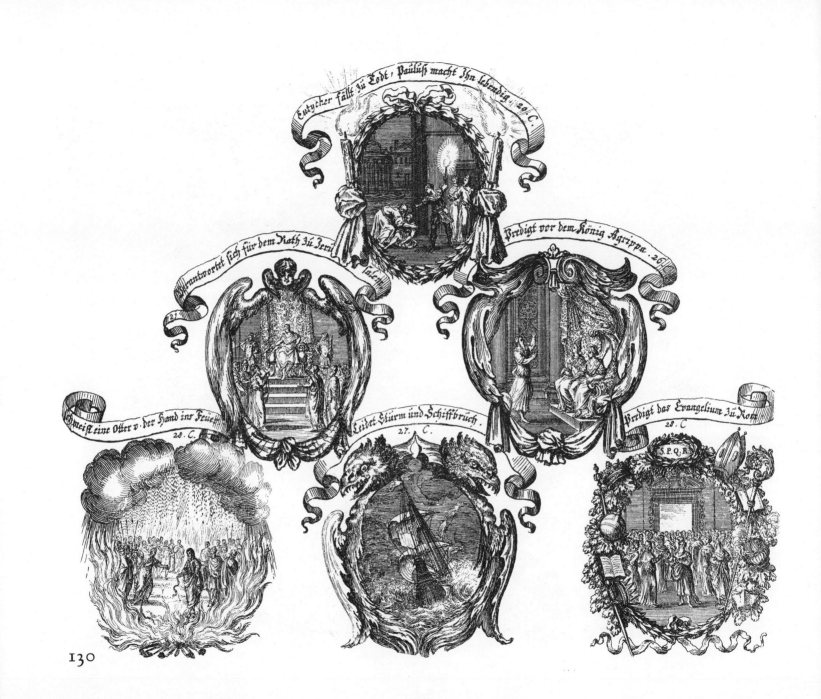

Eutycher fällt zu Todt, Paulus macht ihn lebendig. 20. C.

antwortet sich für dem Rath zu Jeru... salem.

Predigt vor dem König Agrippa. 26.

Schmeißt eine Otter v. der Hand ins Feüer. 28. C.

Leidet Sturm und Schiffbruch. 27. C.

Predigt das Evangelium zu Rom. 28. C.

S. P. Q. R.

130

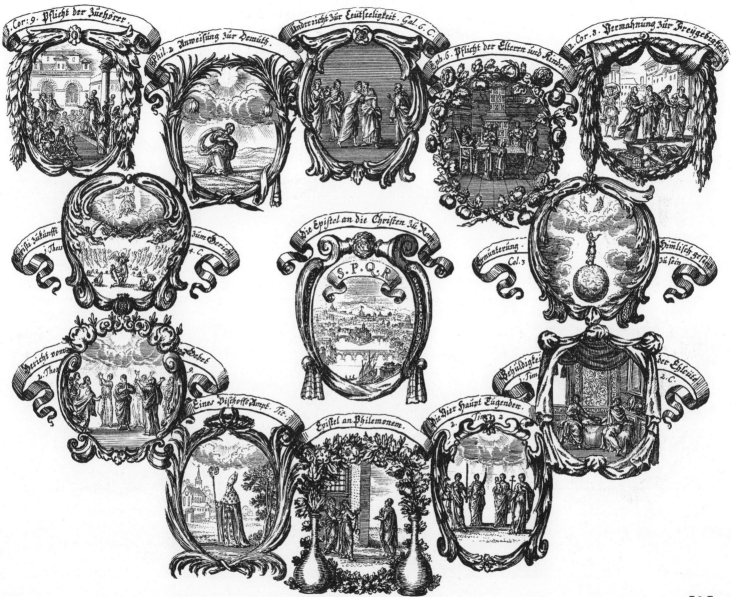

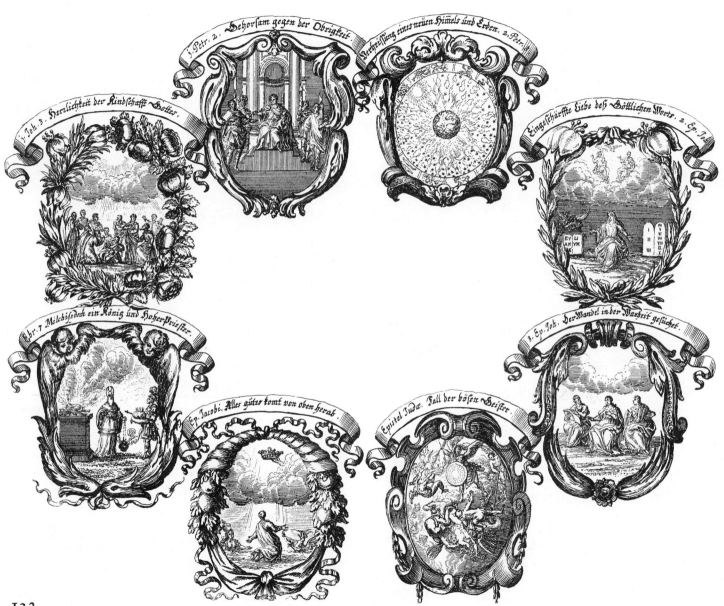

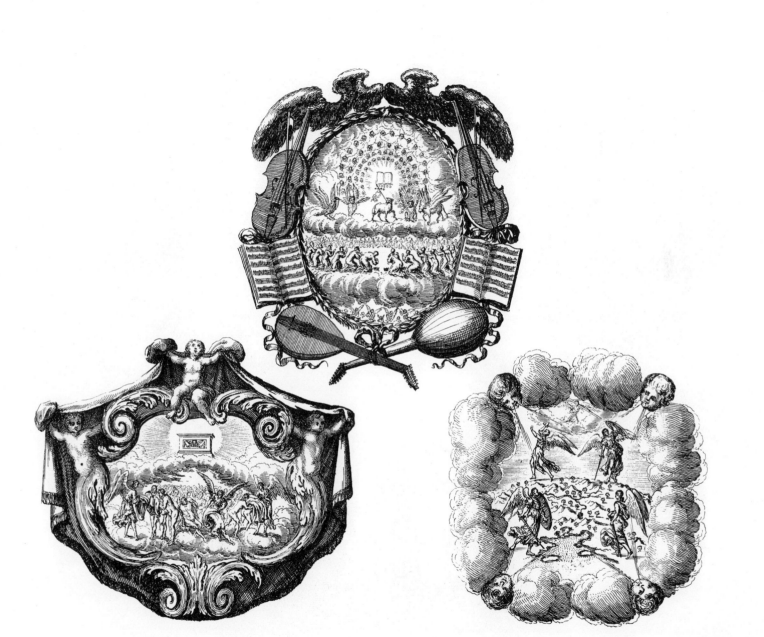

133

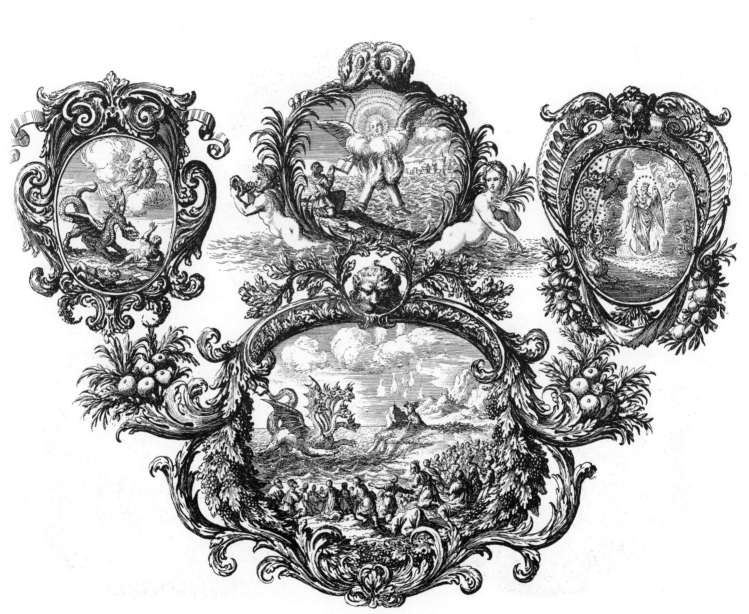

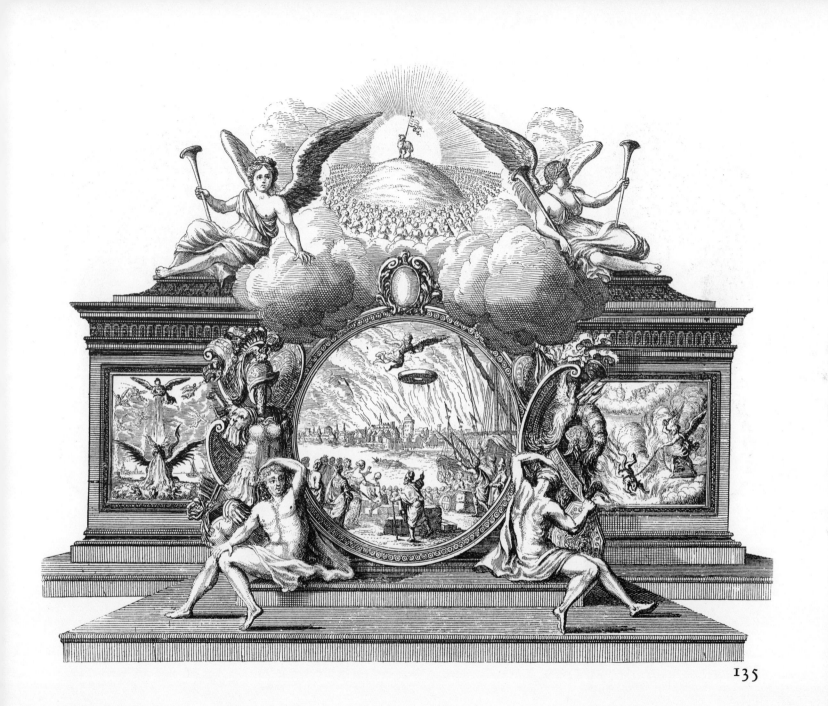

135

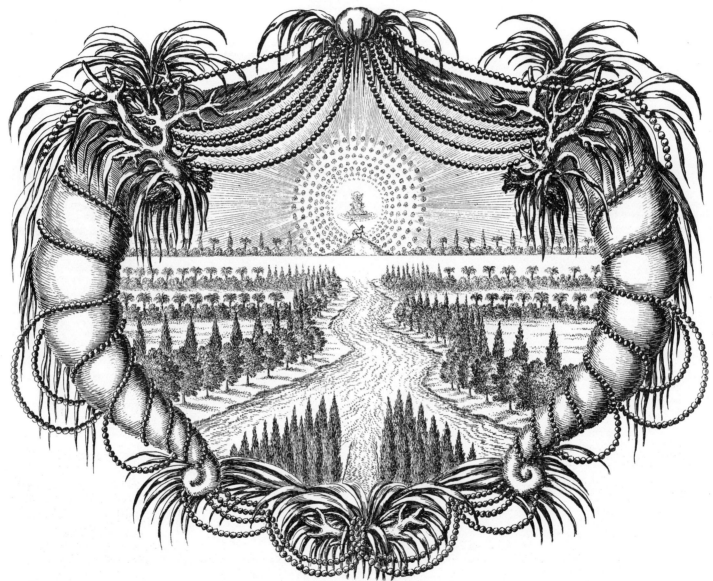

136